TADAO ANDO

Kenneth Frampton

TADAO ANDO

THE MUSEUM OF MODERN ART · NEW YORK

The exhibition and catalogue are part of the
Gerald D. Hines Interests Architecture Program
at The Museum of Modern Art, New York.

Distributed by Harry N. Abrams, Inc., New York

This book was originally published on
the occasion of the exhibition *Tadao Ando*
October 3 – December 31, 1991
organized by Stuart Wrede, Director
Department of Architecture and Design
The Museum of Modern Art

The exhibition and catalogue were part of the
Gerald D. Hines Interests Architecture Program
at The Museum of Modern Art, New York.

The exhibition was also sponsored by
Yoshida Kogyo K.K.

Produced by the Department of Publications
The Museum of Modern Art, New York
Osa Brown, Director of Publications

Edited by Harriet Schoenholz Bee
Designed by Tomoko Kawakami Miho
Production by Marc Sapir

Typeset by TGA Communications, Inc., N.Y.
Printed by Allied Printing Services, Inc., Manchester, Conn.
Bound by Mueller Trade Bindery Corp., Middletown, Conn.

Printed in the United States of America

Published by The Museum of Modern Art
11 West 53 Street, New York, New York 10019

Distributed in the United States and Canada by
Harry N. Abrams, Inc., New York
A Times Mirror Company
Distributed outside the United States and Canada by
Thames and Hudson, Ltd., London

Cover:
Tadao Ando. Church of the Light, Ibaraki, Ōsaka, 1987–89.
Plan rendering

Frontispiece:
Tadao Ando. Nakanoshima Project II: Urban Egg/Space Strata,
Ōsaka, Project 1988. Sketch

Contents

The fifth and final exhibition in the Gerald D. Hines Interests Architecture Program at The Museum of Modern Art is devoted to the work of the Japanese architect Tadao Ando. His spare and subtle buildings, of concrete and glass, offer a contemporary synthesis of modern occidental and Japanese traditions, and constitute an important and influential body of work. The exhibition focuses on ten projects that reflect the developing interaction between Ando's buildings and nature, as well as his refinement of interior architectural space.

Most of Tadao Ando's earlier work, situated in urban areas, responded to often chaotic surroundings by turning inward around courtyards protected by enclosing concrete walls, as exemplified by the Kidosaki House. In more recent commissions for cultural and religious buildings he has had an opportunity to build in the natural landscape, where he has integrated built form with nature in new ways—opening out to it at the Children's Museum, Hyōgo, or burrowing into it at the Forest of Tombs Museum, Kumamoto, and the Chikatsu-Asuka Historical Museum, Ōsaka. Ando's proposal for Nakanoshima has focused his interest in integrating landscape, urban design, and interior space. In this project, the architect, who has been highly critical of Japan's cities, offers an alternate vision of their renewal.

Highly sensitive to nature, but with a dearth of nature to respond to in his early work, Ando honed his subtle sensibility and minimalist architectural vocabulary, manipulating the delicate play of light on stark concrete walls and capturing within the buildings themselves the shifting atmospheric changes of the sky—thus intensifying the experience of nature. This intensity is not only present in the two domestic buildings included here, the Kidosaki and Koshino houses—one urban, the other suburban—but most notably in three modestly scaled, but remarkable, Christian chapels designed and built between 1985 and 1989. The serenity of his spaces and the exquisite play of light and shadow have here created a truly sacred architecture.

In his ecclesiastical buildings, Ando often uses Shintō, Buddhist, and Christian forms interchangeably, or alters a conventional symbol. In the Church on the Water, for

example, he has expanded the traditional meaning of a central Christian symbol: the cross. Usually placed alone, the crucifix carries a complex iconography associated with sacrifice, atonement, redemption, and resurrection. In the Church on the Water, by placing four monumental crosses in a square, Ando has evoked a whole set of other associations: primitive ritual, solidarity, and joyous celebration. It is a profoundly moving image, appropriate for a chapel devoted mainly to weddings, but universal in its meaning as well.

On behalf of The Museum of Modern Art, I wish to thank Tadao Ando for his enthusiasm and cooperation in making this exhibition a reality. Yumiko Ando, his wife and colleague, provided invaluable help in coordinating the Museum's efforts with those of the Tadao Ando architectural office in Ōsaka, and in translating correspondence as well as Ando's text for this catalogue. I would also like to acknowledge the assistance of Kazuya Okano of Ando's office and architect George Kunihiro in New York, who provided much-appreciated help in pulling the exhibition together.

Kenneth Frampton was one of the first architectural historians to realize the importance of Tadao Ando's work and, through his writings, to make the work known internationally; I am indebted to him for providing this volume with its insightful essay. I would like to thank Harriet S. Bee, Managing Editor in the Department of Publications, for her skillful editing of the texts and for cheerfully guiding the catalogue through to completion. Thanks also go to Osa Brown, Director of Publications, and Marc Sapir, Assistant Production Manager, whose efforts have made the publication a reality. Special gratitude is owed Tomoko Miho, who is responsible for the sensitive and elegant design of this volume.

Among other colleagues on the Museum's staff I particularly wish to acknowledge Sue B. Dorn, Deputy Director for Development and Public Affairs; James S. Snyder, Deputy Director for Planning and Program Support; Richard L. Palmer, Coordinator of Exhibitions; Jerome Neuner, Director of Exhibition Production; Jeanne Collins, Director of Public Information; Joan Tenney Howard, Director of Special Events; John L. Wielk, Manager, Exhibition Funding; Blanche Kahn, Associate Registrar; and Michael Hentges, Director of Graphics. All have contributed significantly to the exhibition's realization.

In the Department of Architecture and Design, I would like to thank Matilda McQuaid, Assistant Curator, for her invaluable efforts in coordinating all aspects of the exhibition, and Leanne Pudick, Assistant to the Director, who astutely and efficiently handled everything else.

I would also like to extend the Museum's deep appreciation to Yoshida Kogyo K.K. for its enthusiasm and enlightenment in agreeing to co-sponsor this exhibition. Finally, I wish to extend my thanks to Hines Interests for sponsoring the exhibition and for providing The Museum of Modern Art with the unique opportunity to present, over the past six years, this important series of five exhibitions on contemporary architecture.

Stuart Wrede

Director
Department of Architecture and Design
The Museum of Modern Art

Born in Ōsaka in 1941, Tadao Ando first came to the fore in 1976 with his prize-winning Row House (Azuma Residence), Sumiyoshi. Self-taught, save for a brief apprenticeship with a Japanese carpenter, Ando emerged almost overnight as an architect of world stature without ever attending a school of architecture or serving as an assistant to a master architect. Pressed to give an explanation of his unusual development as an architect, he will only admit to two influences: the spiritual depth of Japanese building culture and the study tours that he made during the second half of the sixties. His output has been prolific: well over forty buildings since he opened his own office in 1969.

More than any other contemporary figure, Ando has been the architect of the reinforced concrete wall, creating volumes delimited by such boundaries, not only in order to define space but also to form it in such a way as to admit and reveal an ever-changing pattern of light (fig. 1). Aside from employing walls as domain-defining planes, Ando has also exploited the wall as a datum against which to read an internal armature of freestanding columns and beams.

From his self-consciously cross-cultural position, Ando sees the reinforced concrete frame as a universal twentieth-century technique, which for all its manifest advantages, has robbed the central Shintō column—the so-called *daikokubashira*—of its symbolic potency (fig. 2) and the classical colonnade of its plastic rhythm. At the same time, he regards the wall as a protective shield that is categorically opposed to the infinite space-field of the modern megalopolis. In Ando's work the court house is seen as the provider of a calm, character-forming, restorative domain wherein the individual may escape the turmoil of the tertiary-industry city and regain some sense of domestic tranquility. In his seminal essay of 1978, titled "The Wall as Territorial Delineation," Ando wrote:

The cheap sprawl and crowded conditions of the modern Japanese city reduce to a mere dream the liberation of space by Modern Architectural means and the resulting close connection between interior and exterior. Today, the major task is building walls that cut the interior off entirely from the exterior. In this process, the ambiguity of the wall, which

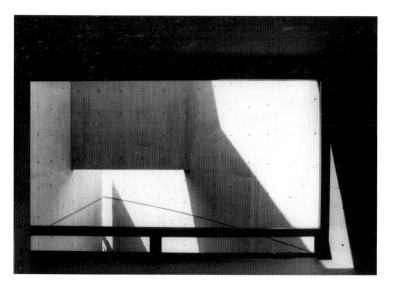
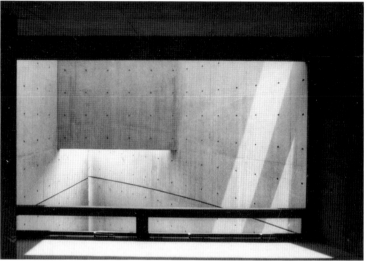
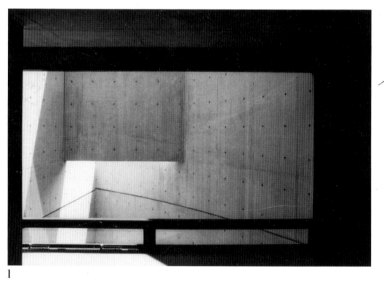

1

1
Tadao Ando. Atelier in Ōyodo, Ōsaka, 1981–82. Views of light court at 10 a.m., 12 noon, and 1 p.m.

is simultaneously interior on the inner side and exterior on the outer side, is of the greatest significance. I employ the wall to delineate a space that is physically and psychologically isolated from the outside world. . . .

I think walls can be used to control walls. In this [Matsumoto] house, walls standing independent in the world of nature delineate a territory for human habitation. Inexpressive in themselves, the two major bounding walls are protective devices for the interior. At the same time they reflect the changes taking place in the world of nature and help to introduce this world into the daily lives of the inhabitants. The limiting operation of the walls directly reveals the boldness of the house itself.[1]

Within the Japanese philosophical tradition, nature manifests itself as two interrelated but opposed aspects, the tangible and the ineffable, that is to say, the palpability of the natural forest landscape as it literally encroaches onto the terrace of his Wall House (Matsumoto Residence), Ashiya, Hyōgo (fig. 3), and the equally apparent intangibility of light and other changing climatic elements as these are consciously integrated into all of Ando's work. As he was to write of the Koshino House, completed in the pinewoods of Ashiya in 1981: "Light is a mediator between space and form. Light changes expressions with time. I believe that the architectural materials do not end with wood or concrete that have tangible forms, but go beyond to include light and wind which appeal to our senses."[2] And, moreover, not only light and wind but also rain, snow, and fog are to be directly experienced as one traverses, for example, the open courtyard of the Azuma Residence in order to pass from one room to the next (figs. 4 and 5). Although this is the most extreme of Ando's houses, it nonetheless testifies to an underlying stoicism that is evident in all of his architecture. Paradoxically for one who has been frequently commissioned by the Japanese fashion industry, Ando remains opposed to the ubiquitous triumph of modern comfort and consumerism that is as prevalent in Japan as elsewhere. In this respect, functionalism is a contradictory concept for Ando, an ergonomic value that first has to be satisfied and then partially denied.

I am interested in discovering what new life patterns can be extracted and developed from living under severe conditions. Furthermore I feel that order is necessary to give

2
Izumo Shrine, Izumo, Shimane.
Longitudinal section showing sacred column
at the center of the structure

*life dignity. Establishing order imposes restrictions, but
I believe it cultivates extraordinary things in people.*

*I believe in removing architecture from function after
ensuring the observation of functional basics. In other words,
I like to see how far architecture can pursue function and
then, after the pursuit has been made, to see how far
architecture can be removed from function. The significance
of architecture is found in the distance between it and
function.*[3]

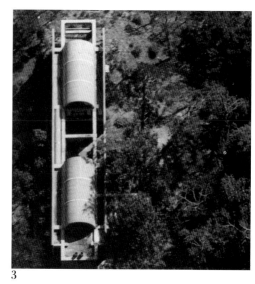

3

This idea of a gap, be it physical or metaphysical, is
constantly present in all of Ando's architecture, and the level
and nature of its appearance varies considerably from one
work to the next and even among different sectors of
the same work. Seen in this light, a courtyard becomes a
space within which the ubiquitous void may be rendered
perceivable, partly through changes of light and climate, and
partly through the changing ethos of the space itself. This is
close to the idea of *yugen* in Japanese poetry, wherein the
ineffable presence of living nature is sensed through such
things as a faint drizzle or a sudden unexpected breeze, the
onset of twilight or the premonition of dawn.[4]

All of this is implied in the layered plan of the Koshino
House, which is inscribed into the surrounding topography
in such a way as to expose the principal rooms to the
full trajectory of the sun (page 26). However, sunlight enters
more precipitously into this house from above, through a
narrow slot cut into the roof at its junction with the wall.
From this aperture a single interrupted shaft of light
descends to run its ever-changing luminous course across
the adjacent concrete wall that runs the full length of the
living room. The concrete face of this plane seems to have
been treated in such a way as to effect its dematerialization
under the impact of sunlight, to illuminate, through the
continual movement of the sun, the latex sheen of its subtly
undulating surface (page 28). A similar light slot is let
into the roof of the radial studio, added to the northern face
of the house in 1984. In this instance, the pattern of
changing light becomes increasingly organic in shape as it
falls onto a continuously curved wall (fig. 6 and page 29).

The Koshino House features a totally different kind of
luminosity within its interior, where a shadowy darkness of
somewhat uncertain depth emanates from the concrete-
lined corridor linking the living volume to the bedroom

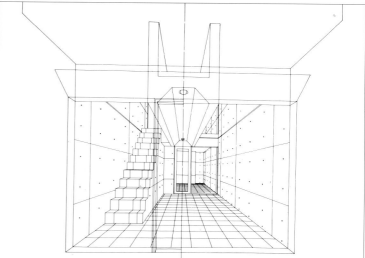

4

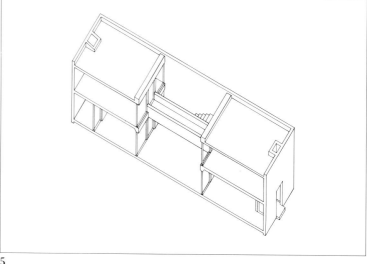

5

3
Tadao Ando. Wall House
(Matsumoto Residence), Ashiya,
Hyōgo, 1976–77. Aerial view

4
Tadao Ando. Row House
(Azuma Residence), Sumiyoshi,
Ōsaka, 1975–76. Interior perspective

5
Tadao Ando. Row House
(Azuma Residence), Sumiyoshi,
Ōsaka, 1975–76. Axonometric

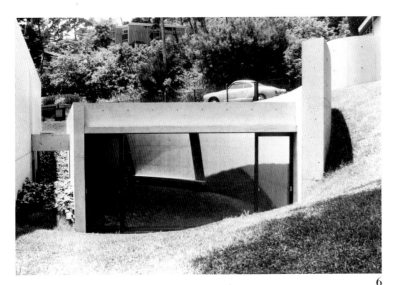

6

block. Here we are close to that traditional Japanese space of darkness, characterized by the novelist Jun'ichirō Tanizaki in his highly influential critique of Westernization, which first appeared in print under the title *Inei raisan (In Praise of Shadows)* in 1934. Tanizaki was to describe the symbiosis between Japanese secular and sacred light in terms that seem to parallel the varying levels of luminosity to be found in many of Ando's interiors:

Whenever I see the alcove of a tastefully built Japanese room, I marvel at our comprehension of the secrets of shadows, our sensitive use of shadow and light. For the beauty of the alcove is not the work of some clever device. An empty space is marked off with plain wood and plain walls, so that the light drawn into it forms dim shadows within emptiness. There is nothing more. . . . We are overcome with the feeling that in this small corner of the atmosphere there reigns complete and utter silence; that here in the darkness immutable tranquility holds sway. . . .

In temple architecture the main room stands at a considerable distance from the garden; so dilute is the light that no matter what the season, on fair days or cloudy, morning, midday, or evening, the pale, white glow scarcely varies. And the shadows at the interstices of the ribs seem strangely immobile, as if dust collected in the corners had become a part of the paper itself. . . . The light from the pale white paper, powerless to dispel the heavy darkness of the alcove, is instead repelled by the darkness, creating a world of confusion where dark and light are indistinguishable. Have not you yourselves sensed a difference in the light that suffuses such a room, a rare tranquility, not found in ordinary light? Have you never felt a sort of fear in the face of the ageless, a fear that in that room you might lose all consciousness of the passage of time, that untold years might pass and upon emerging you should find you had grown old and gray?[5]

As susceptible as Tanizaki to the transformation of traditional light under the impact of modernization, Ando has constantly tried to render his work as a subtle interface in which the two civilizations are brought to confront each other. To this end, he has created an object-world in which the value of the one, the proliferating occident, is brought into opposition with the value of the other, the sequestered orient. This dialogue is expressed in the living room of the Koshino House by two features: by a dining

6
Tadao Ando. Koshino House and Studio,
Ashiya, Hyōgo, 1979–84.
View of studio addition (1984)

table that cantilevers beyond the dining recess above a portion of the main living floor so that occidental and oriental sitting postures may be adopted at the same table, and by the heights of two windows giving onto the garden and patio, respectively. Where the first of these windows extends to head-height in the usual occidental manner, the second brings the opening down to just below the average standing height, that is, to a level more in keeping with Japanese stature and posture (page 29).

This occidental/oriental dyad constantly crops up in unexpected ways throughout Ando's architecture. It is patently evident in the sameness and difference evoked by the juxtaposition of glass-block fenestration with traditional *shōji*, in the inner and outer facades of the *tatami* room on the ground floor of the Glass Block House (Ishihara Residence), completed in Ikuno, Ōsaka, in 1978 (fig. 7). A similar dialogue is present in the first phase of his Rokko Housing complex, realized on a precipitously steep site overlooking Kōbe Bay, in 1983 (figs. 8 and 9). Here, as in the so-called Step development built at Takamatsu, Kagawa, in 1977–80, Ando tries to combine two totally different kinds of public spaces; the oriental *roji*, or narrow alley, as drawn from the residential labyrinth of the traditional Japanese city (fig. 10), and the occidental plaza, which appears in modified form halfway up the inclined access spine running vertically through the center of the Rokko complex. This hybrid space is further enriched by being deliberately organized, in Ando's phrase, as a "discontinuous-continuity" in which, save for climbing a nine-story stairway, one can only traverse the full height of the stepped settlement by changing elevators at mid-point and crossing from one to the other across the *roji*/plaza (see also Row House, Sumiyoshi, figs. 4 and 5). For Ando this discontinuous-continuity is seen as an essential attribute of the elusive concept *Ma*, which not only signifies place but also the idea of the consummation of space through the action of a body crossing from one point to another, in much the same way as an electric spark jumps across a gap.

Discontinuous-continuity may be said to characterize the confrontation between occidental and oriental values that permeates Ando's architecture at every conceivable level. This disjunctive principle is made even more explicit in the Chapel on Mt. Rokko, built in Kōbe, Hyōgo, in 1985–86, as part of a resort-hotel complex (page 34). Here two countervailing notions of the spiritual are juxtaposed

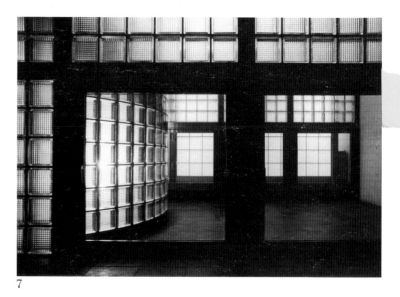

7

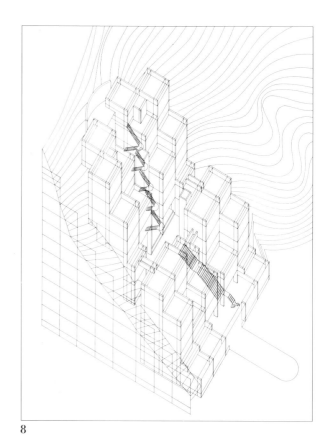

8

7
Tadao Ando. Glass Block House (Ishihara Residence), Ikuno, Ōsaka, 1977–78. View across courtyard toward *tatami* room

8
Tadao Ando. Rokko Housing I, Kōbe, Hyōgo, 1978–83. Axonometric

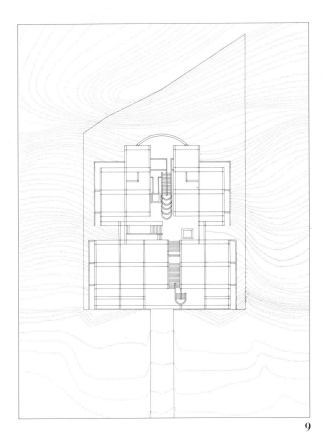

9

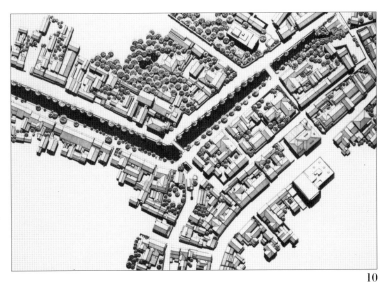

10

9
Tadao Ando. Rokko Housing I, Kōbe, Hyōgo, 1978–83. Site plan showing square elevator shafts at opposite sides of the central *roji*/plaza
10
Typical traditional Japanese town plan with *roji* (canal district, Kurashiki, Okayama)

side by side, so as to effect an abrupt contrast between the significance of the crucifix and the empty silence of the void; to oppose, that is, the sign of the West with the non-sign of the East.

In this work, the only ordained space is the basilica itself. However, this form is preceded by an intercolumniated arcade, lined and roofed with large sheets of frosted glass (fig. 11). Affording a visually contained approach from the hotel to the chapel, this perspectival space terminates in a void at the crest of the hill, thereby focusing on the datum between sky and ocean that has long been an embodiment of the sacred in Japan. Only a stepped descent at the end of this long, processional Shintōesque volume gives any indication as to the transitional space that will open onto the chapel at the end of the arcade. Ando himself has remarked on the referential nature of this volume to the Fushimi Inari Shrine in Kyōto, where hundreds of *torii* (Shintō post-and-lintel gates) line the route to the sacred precincts (fig. 12).

Once one enters the chapel, the presence of nature is reasserted through a full-height glass wall let into one side of the basilica. Divided by an inverted concrete cruciform into four large panes, this window-wall opens onto a banked courtyard, bounded by a dwarf wall known by the name *tsukiji*. As in the famous rock garden of Ryōanji Temple, Kyōto, this wall extends for a seemingly infinite distance to the right-hand side of the space. In re-presenting nature as the ultimate repository of the divine, Ando splits the focus of the chapel between a steel crucifix suspended at the end of the nave and the tranquility of an embanked court covered with gardenias. The entire sequence thus breaks down into three interrelated spiritual domains: arcade, basilica, and court.

Ando's habitual reliance on geometry is particularly in evidence here, where three circles of the same radius control the interval and the sectional profile of these spaces (fig. 13). Similarly, the dimensions of the basilica are precisely related to the square modular bay of the arcade. The chapel is thus two-and-a-half bays wide by five bays deep while the arcade extends for fifteen bays in length, ten of which elapse before the floor steps down to continue with the last five bays of the total run. The double-square plan of the basilica divides in length into three different parts — entry, nave, and altar — having the proportions of one-two-

one, respectively, with the window-wall lining one side of the nave for its full extent. This glazed wall is divided vertically into a complementary three-to-one modular proportion, the underside of the cruciform transom being one-fourth of the total height (page 37).

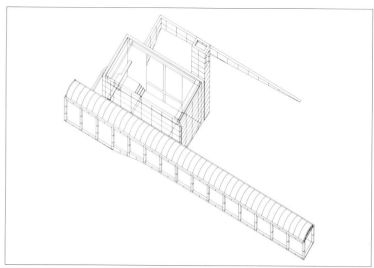

11

Ando's involvement with nature becomes more topographic and expansive as the scope of his practice changes and as the sites become increasingly bucolic. This shift is particularly noticeable in the so-called Church on the Water, completed at Tomamu, Hokkaidō, in 1988, which is positioned so as to take maximum advantage of the undulating, forested prospect which it faces (fig. 14 and page 43). While the sign of the cross is even more prominent in this composition, its traditional significance is weakened through its quadruplar repetition within a glass enclosure. Since the four crosses are absolutely symmetrical and equal on all their respective axes and since they also almost touch each other at their extremities they thereby deny the traditional orientation of the Christian Church and in so doing imply a totally other idea of the godhead. The resultant spatial figure, voided at the center, insists upon a totally panoramic reading of the landscape.

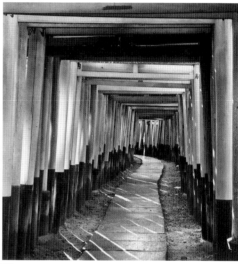

12

To enter the church, the visitor climbs up within this ferro-vitreous prism to the level of the crosses, and after traversing this stair, completes the descent via a curved staircase into the half-cubic volume of the chapel itself. Here we are presented with the contemplative space of the chapel, which opens onto a subtly articulated vista comprising a freestanding steel cross standing in the midst of a shallow artificial pool. Patently influenced by Kaija and Heikki Siren's Otaniemi Chapel of 1957 (fig. 15), this highly symbolic vista is separated from the outside by a fifty-by-twenty-five-foot glazed wall capable of being moved away in summer so as to expose the chapel totally to the open air. Since the track of this sliding wall is sustained by a concrete frame that outlines, as it were, the absent elevation of the church, we seem to lie suspended here between two divergent references, that is to say, between the parallel domains of the Ise Shrine, the one in use, the other lying fallow (fig. 16), and the romantic animistic visions of Caspar David Friedrich, wherein the mirage of a cross becomes assimilated to a pine tree.

The development at Tomamu is intended to embrace an even more complex cultural synthesis in the form of Ando's

11
Tadao Ando. Chapel on Mt. Rokko, Kōbe, Hyōgo, 1985–86. Axonometric
12
Fushimi Inari Shrine, Kyōto. A row of *torii* flanking the long approach to the shrine

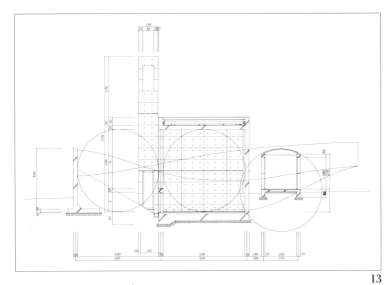

13

14

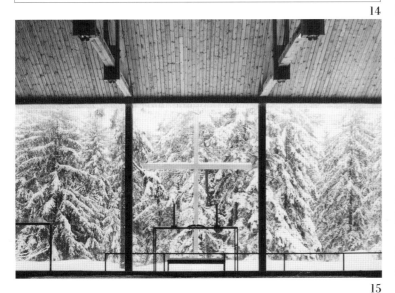

15

proposal for a Theater on the Water, also to be located on a wooded site, some 1,300 feet to the northwest of the church. Built around a fan-shaped artificial pond, fed from the same stream as the church's, this 6,000-seat amphitheater is intended to be used for a wide range of public events, including concerts and fashion shows (page 49). Once again, occidental and oriental references are equally in evidence as the poles of a double dialogue. The amphitheater is clearly Greek in origin except for the fact that the orchestra and stage are absent, their traditional locations being flooded with water. Their place is assumed by a suspended runway cutting across the amphitheater and intersecting, as it does so, a row of freestanding columns that serve to establish the diameter of the theatral space. These intersecting trajectories would seem to derive from two different cultural memories. Thus, where the colonnade stands in place of an absent proscenium, the interpenetrating runway alludes to the traditional "pontoon bridge" of the Kabuki stage (fig. 17). Once again we encounter Ando's practice of deploying oriental type-forms in such a way as to qualify the Western paradigms with which they are integrated.

Much the same phenomenon occurs in the Church of the Light, built at Ibaraki, Ōsaka, in 1987–89 (page 38), where, despite the traditional eastern end, radiating light, the form as a whole stems as much from the concrete Tea House (fig. 18), which Ando added in 1982 to his 1976 Soseikan Houses (Yamaguchi Residence), as from the truncated basilica form that snugly accommodates the congregation of this small church. Both tea house and church are enclosed by a *roji*, or alleyway, that, in each specific instance, turns out to be a "vestigial" approach to the space. In the Soseikan Tea House, the *roji* leads to a *nijiriguichi*, or traditional "crawl door," that, since it is not a door but a fixed sheet of plate glass, both invites and precludes entry. Similarly, in the Church of the Light, steps leading down into the *roji* imply an approach that is abruptly denied by an angular space that instantly terminates in a plate-glass window-wall, which, while it gives on to the interior, fails to provide access.

In contrast to the introspective character of his earlier work, the Tomamu complex and the Time's Shops, built along the banks of the Takase River, Kyōto, in 1983–88, testify to Ando's growing interest in extending the influence of his work into the surrounding topography, even if the *shakkei*, or borrowed scenery, of the Church

13
Tadao Ando. Chapel on Mt. Rokko, Kōbe, Hyōgo, 1985–86. Section with superimposed circles
14
Tadao Ando. Church on the Water, Tomamu, Hokkaidō, 1985–88. Plan
15
Kaija and Heikki Siren. Chapel, Institute of Technology, Otaniemi, Espoo, Finland, 1957. View of crucifix from interior

and Theater on the Water remains as yet incomplete.

What was intended in the case of the two buildings at Tomamu was to be more fully realized in the Children's Museum, completed in 1989 on a dramatic site near Himeji, Hyōgo. Carefully positioned on a promontory overlooking a large lake, the principal museum building assumes the form of a prowlike acropolis facing southwest toward the water and approached by a serpentine road traversing the northern reach of the lake (page 54).

The inspiration in this instance could hardly be more Greek, the museum appearing like an isolated citadel as one approaches it from the north to arrive finally at an elevated parking court situated to the south of the main complex. The subsequent pedestrian approach is equally imposing since one descends from the high ground via a monumental flight of steps, all the while looking over the full length of the lake as it loses itself in the foothills lining its southern shore. That this grand staircase is paralleled by a water-stairway cascading down over virtually the same section, only adds to the monumental aura of the approach. Compared to Tomamu, the *shakkei* waterscape is brought to a finer level of resolution at Himeji, as the tiered reflecting pools fan out against the curving prow of the museum, fusing the metallic sheen of their surfaces with the distant waters of the reservoir (page 55).

The museum is entered after this dramatic descent through an open, but covered, cruciform court that divides the twin slabs of the institution into four separate blocks. The stepped section of the open-air amphitheater crowning the assembly appears to echo the profile of the nearby mountains and thus evokes the sense of *oku* permeating much of Ando's recent work.[6] This traditional sensibility implies a certain spatial and spiritual depth extending from the domestic *tokonoma*, or alcove, to the outer reaches of the paddy fields and then beyond to a shrine in the foothills, and ultimately to the vastness of the peak itself.

Surrounded on all sides by reflecting pools, the museum engages in a subtle proportional play comprised of squares, cubes, and golden sections that serves to define and articulate the various halls and mezzanines of which its volume is composed. This strictly orthogonal prism is offset by outriding diagonal walls and paths that extend into the undulating topography to link eventually with a

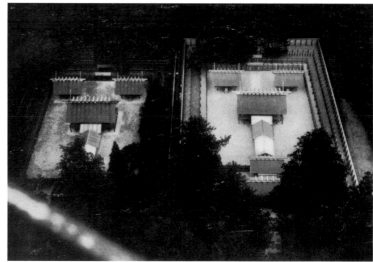

16

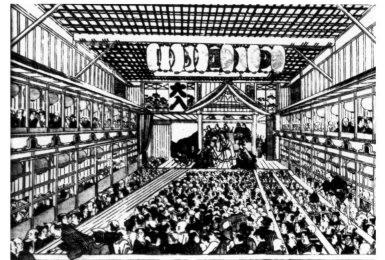

17

16
Ise Shrine, Ise, Mie. Aerial view showing old buildings and fences alongside identical new ones. Every twenty years (since the seventh century) the shrine is rebuilt on an adjoining site.

17
Traditional Kabuki theater with a play in progress, depicted in a print, signed *Shunrō*, c. 1794

workshop building situated to the northeast. The resultant trajectory, pre-Columbian rather than Greek, runs out through a nine-square, sixteen-column belvedere from which one looks back over the museum and the reservoir (page 59). This dynamically structured landscape, traversing a more-or-less virgin site, will be soon complemented by a Seminar House, or children's hostel and observatory, situated some 1,000 feet to the southeast of the museum and comprising a small cluster of freestanding buildings rising out of a fractured acropolis.

This last initiates a whole series of topographic projects by Ando that are now in various stages of development. These include the Chikatsu-Asuka Historical Museum, Ōsaka, the Forest of Tombs Museum, Kumamoto, and the so-called Water Temple for Hompukuji monastery on Awaji Island in Ōsaka Bay.

Part necropolis and part amphitheatral stairway, the Chikatsu-Asuka Historical Museum amounts to a visitors' center for the study of some two hundred ancient tumuli that are scattered throughout the region (page 68). The work is thus conceived as a "time machine," that is to say, as a subterranean device for experiencing the past rather than as a museum in the conventional sense. To this end, the undercroft of the esplanade-stairway is rendered as a sarcophagus in which the excavated relics of the various tumuli will be exhibited. Nothing could be further from this telluric gloom than the observation tower, planted in the midst of a stepped podium, which affords views over the entire region. Since the podium steps will be dedicated to occasional performances of various kinds, the entire complex will serve as a place of pilgrimage.

Once again, a dialogical play with opposites permeates the work so that the square atrium let into the podium is complemented by a square tower of exactly the same dimensions in plan. This opposition is paralleled by the dialogue between the stepped podium and the diagonal ramp and by the contrast between the open atrium and the shadowy void within the space of the tower.

A work of comparable subterranean intensity is to be found at the heart of the Awaji Water Temple, as we may

18
Tadao Ando. Soseikan Houses
(Yamaguchi Residence) and Tea House,
Takarazuka, Hyōgo, 1974–82. Plan
of twin houses with tea house (1982)
at bottom right

appreciate from the three stages of the approach to the nexus of the composition, first a large concrete wall concealing the presence of the precinct, then a labyrinthine path terminating in an elliptical pond covered with water lilies (page 50). The supplicant descends by stair through this lotus-covered surface, into a subaqueous space that will be largely occupied by a cylindrical volume filled with columns. In the most recent version, these have been reduced to a skeleton of columns lining the perimeter. In the center of this pillared hall, the visitor will finally encounter the image of a Buddha backlit from the west; the low afternoon sun heightening the luminosity of the traditional red interior.

Such womblike chambers have appeared elsewhere in Ando's recent work, most notably perhaps in his comprehensive proposal for the redevelopment and refurbishing of Nakanoshima, situated in the middle of downtown Ōsaka (pages 70–71). This elaborate, partially subterranean project, reminiscent of Étienne-Louis Boullée (famous for his 500-foot-diameter spherical monument to Sir Isaac Newton), culminates in a cosmic "egg" that is deftly inserted into the shell of an existing nineteenth-century structure (page 72). This ultramodern auditorium is lit by a myriad of recessed lights set into the inner surface of the shell, suggesting the presence of a science-fiction volume dropped into a classical box.

As the Japanese critic Koji Taki has remarked, Ando is a builder rather than an architect, with all the ontological implications that this has, in a profound sense, for the art of building rather than architecture.[7] Against the classical humanist values inseparable from architecture, Ando sets the palpability of things in all their characteristic purity, whether this is precision casting in concrete or a discrete assembly of handcrafted components built to exacting standards. As architectural historian Masato Kawamukai has written:

Material is an extremely important part of his "concept." It would not be an exaggeration to say that, in his case, a concept is correct only if it suggests a way in which the real character of a material might be expressed, as well as a consequent form of spatial expression. He tries to use material, whether it be natural or factory-produced, in its pure, solid form, without working it. Standardized products such as tiles, concrete blocks and glass blocks are not fragmented but used full-size. Moreover, each material must be an autonomous compositional element even as it serves to shape the space he intends.[8]

In the tradition of Ludwig Mies van der Rohe, Ando tries to take the intrinsic character of any given material and enhance its expressive potential to the highest possible level, to bring to it an essential, indisputable density or radiance. This intention is provoked to extreme limits in the fabrication of concrete where certain strict principles are observed in order to guarantee both density of material and precision of surface. In the first place, the mix itself is of engineering quality, Ando never using a "slump" (the degree to which it settles) greater than approximately six inches. Since complete and thorough vibration of the pour is an absolute prerequisite if one is to produce a concrete free from "pocketing," no reinforcing bar may be set closer than one-and-one-half inches from the inside face of the formwork. To all this must be added the precision joinery of the formwork itself. Ando employs different teams of select carpenters to this express end and even encourages these teams to engage in rivalry with regard to their collective capacities as craftsmen. As a result, Ando's concrete is remarkably stable and, unlike the concrete produced from weaker mixes, it resists the penetration of moisture and thus takes a long time to become stained with rain, even in the heaviest downpour. In this particular regard, it is easy to see why Kawamukai claims that: "Ando has no need of costly or rare materials, since any material will become radiant if it is used in the right way."[9]

Even more astonishing is Ando's rather Zen-like approach to the act of creation itself, conceiving of the entire work in a single instant after a relatively short period of gestation. During this inner formation of the concept, nothing is drawn, at least not by Ando himself. All the constraints of the project are internalized either by Ando alone or, more commonly, in collaboration with his staff who will elaborate and test a number of tentative schemes, suggested by the architect almost in passing. Ando sharpens his concentration, waiting for the moment in which the concept will suddenly reveal itself in its entirety. When that point arrives, the scheme is engendered in a very short period of time, and a single assistant is selected to develop it and to carry it through to completion.

This method produces a kind of absolute architecture—what Ando calls an "original form of space"—wherein geometry and nature are precisely balanced with respect to each other and where, once the die is cast, the purity of the volume housing the accommodation is no longer negotiable. Where there is conflict with the client beyond this point Ando will either carry the day through persuasion or abandon the job.

The fundamental dyad underlying Ando's work comprises the opposition between geometry and nature, although for him nature is as artificial in its mediation as abstract form. This opposition has another level of significance, however, in that Ando regards occidental form-making as irreducibly geometrical, volumetric, and vertical in contradistinction to the traditional Japanese mode of building which can be seen as natural, horizontal, and spaceless. In this respect, Ando's architecture implies a particular synthesis in which, while geometry determines the built, nature either infiltrates the enclosed volume from above, be it open or roofed, or alternatively extends the bounded domain into a recessive landscape.

Ando conceives of our being as the third term, as the living catalyst without which the bond between geometry and nature can never be made. Of this indispensable agent, conceived as the indivisible *shintai*, he has written:

Man articulates the world through his body. Man is not a dualistic being in whom spirit and the flesh are essentially distinct, but a living, corporeal being active in the world. The "here and now" in which this distinct body is placed is what is first taken as granted, and subsequently a "there" appears. Through a perception of that distance, or rather the living of that distance, the surrounding space becomes manifest as a thing endowed with various meanings and values. Since man has an asymmetrical physical structure with a top and a bottom, a left and a right, and a front and a back, the articulated world, in turn, naturally becomes a heterogeneous space. The world that appears to man's senses and the state of man's body become in this way interdependent. The world articulated by the body is a vivid, lived-in space.

The body articulates the world. At the same time, the body is articulated by the world. When "I" perceive the concrete to be something cold and hard, "I" recognize the body as something warm and soft. In this way the body in its dynamic relationship with the world becomes the shintai. *It is only the* shintai *in this sense that builds or understands architecture. The* shintai *is a sentient being that responds to the world. When one stands on a site which is still empty, one can sometimes hear the land voice a need for a building. The old anthropomorphic idea of the genius loci was a recognition of this phenomenon. What this voice is saying is actually "understandable" only to the* shintai. *(By understandable I obviously do not mean comprehensible only through reasoning). Architecture must also be understood through the senses of the* shintai.[10]

As the above would indicate, Ando seeks nothing less than a tectonic transformation of our being through space and time. Set against the profligate waste of our consumerist culture, his art proffers an extremely subtle response to Hölderlin's untimely challenge as to the role of the poet in a destitute age.

Notes

1

Tadao Ando, "The Wall as Territorial Delineation,"
The Japan Architect, no. 254, June 1978, pp. 12–13.

2

Tadao Ando, "Koshino Residence," *Space Design*, no. 201,
June 1981, p. 15.

3

Tadao Ando, "The Emotionally Made Architectural Spaces
of Tadao Ando," *The Japan Architect*, no. 276, April 1980,
pp. 45–46.

4

According to Thomas Rimer, the term *yugen*, in Heian
and Kamakura poetry, alluded to "the representation of
the ineffable or the unseen, a summoning up of what lies
beneath the surface of perceived nature." See Thomas
Rimer, "Introduction," in *From the Country of Eight Islands*,
ed. and trans. Hirokaki Sato and Burton Watson
(Seattle: University of Washington Press, 1981).

5

Jun'ichirō Tanizaki, *In Praise of Shadows*, trans.
Thomas J. Harper and Edward G. Seidensticker
(New Haven: Leete's Island Books, 1977), pp. 20–22.

6

Oku indicates a form of deep or folded space. As Fumihiko
Maki has put it, *oku* obtains when a spatial arrangement is
determined by depth rather than a center. See Fumihiko Maki,
"Japanese City Spaces and the Concept of Oku," *The Japan
Architect*, no. 265, May 1979, pp. 51–62.

7

Koji Taki, "Minimalism or Monotonality? A Contextual Analysis
of Tadao Ando's Method," in *Tadao Ando: Buildings Projects
Writings*, ed. Kenneth Frampton (New York: Rizzoli, 1984), p. 11.

8

Masato Kawamukai, "A Dialogue Between Architecture and
Nature," in *Tadao Ando* (London and New York: Academy
Editions/St. Martin's Press, 1990), p. 11.

9

Ibid.

10

Tadao Ando, "*Shintai* and Space," in *Architecture and Body*
(New York: Rizzoli, 1988), unpaginated.

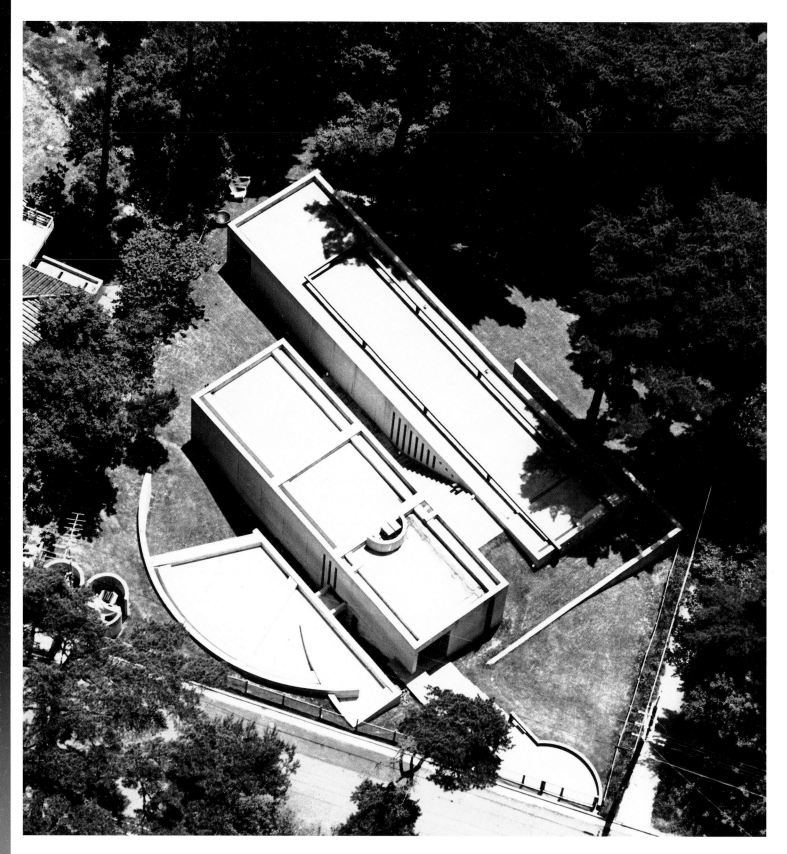

Ashiya, Hyōgo, 1979–81; Studio, 1983–84

Two parallel concrete volumes, linked by an underground corridor, comprise the living quarters of this house on a sloping site in a resort town above Ōsaka. The shorter volume has two levels, the lower floor accommodating a double-height living room, a dining room, and a kitchen area, and the upper level the entry and master-bedroom suite. The longer one-story wing contains seven bedrooms and a bathroom off a single-loaded corridor. The space between the two rectangular wings forms a courtyard that includes a generous span of steps, creating an outdoor living space. A quarter-circle-shaped studio was later added on the other side of the main living volume.

The principal elements of this residence are partially underground. The living room and the studio have skylight bands along the edges of the roof, so that as the sun moves across the sky it plays on the rich texture of the concrete walls and creates a constantly changing pattern of interior shadows.

site plan

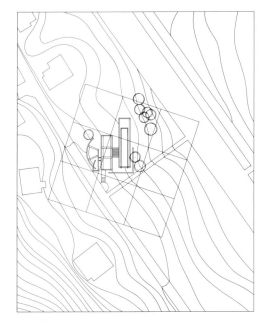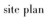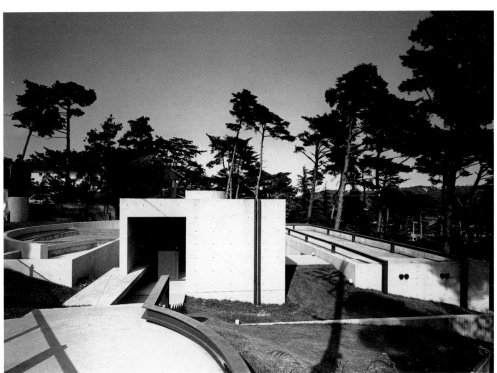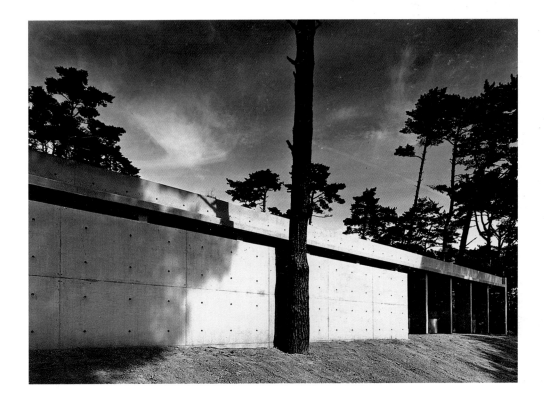

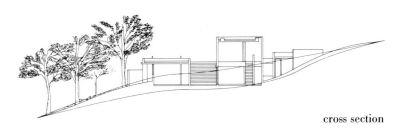

cross section

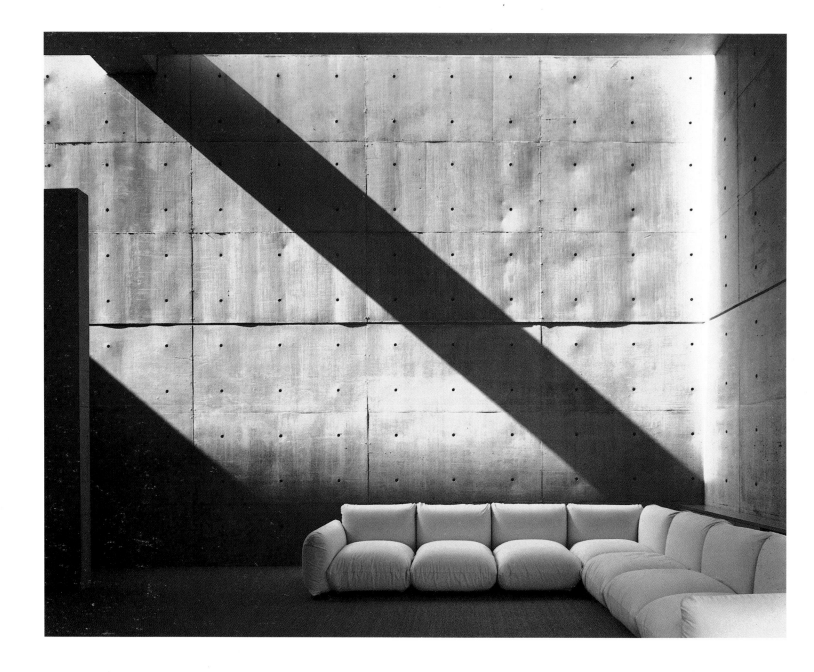

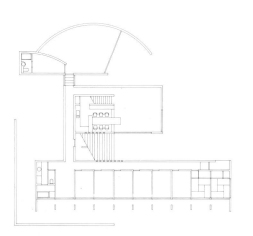

first-floor plan

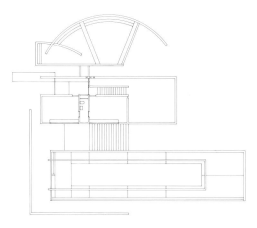

second-floor plan

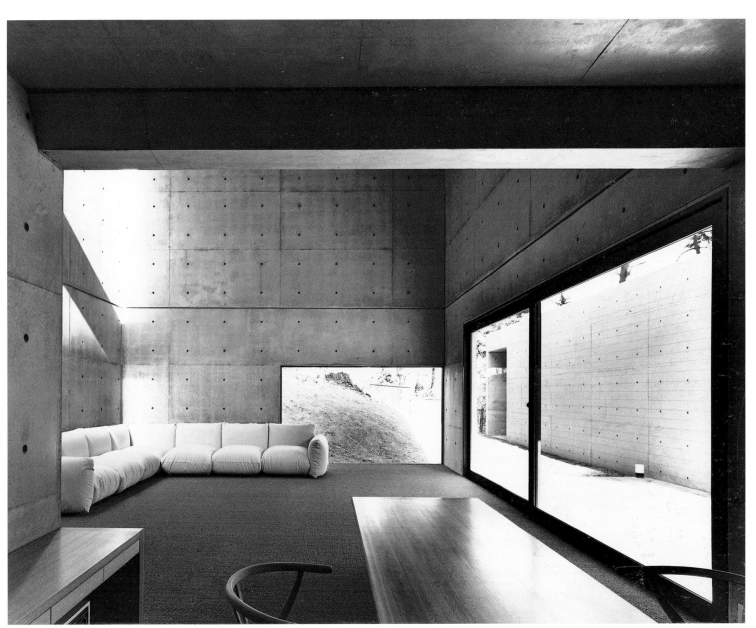

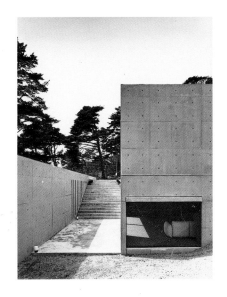

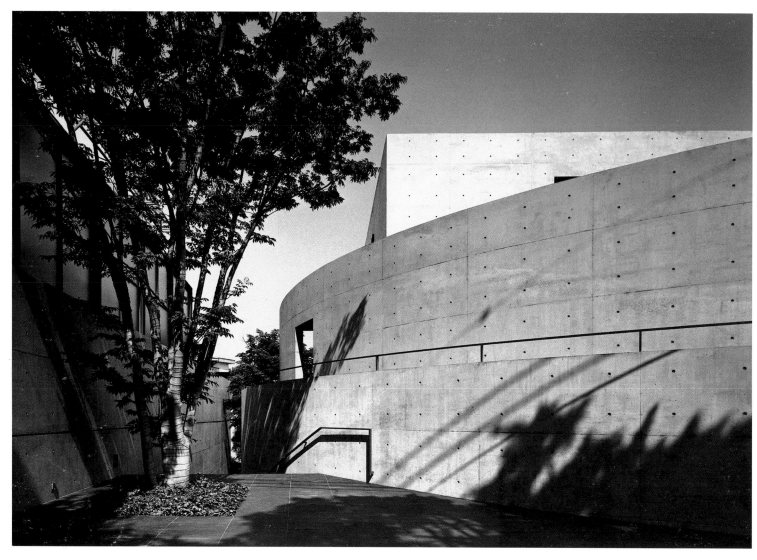

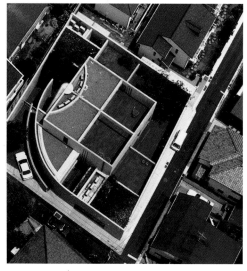

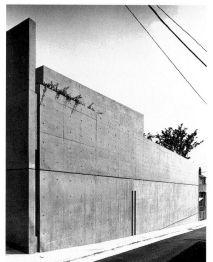

Setagaya, Tokyo, 1982–86

This three-family house was designed for a couple and their parents. The building consists of a three-story cubic volume and two single-story wings extending on opposite sides of the structure to a protective wall along the property line. The two open spaces between the first-floor building elements become a private courtyard for the parents on the south side and an entry court on the north. The young couple's apartment occupies the second and third floors, and the two parents' units the first floor. The second floor, which contains a living/dining room and kitchen, connects via a stair to the double-height living room of one of the first-floor apartments. The third floor houses a bedroom and study as well as a private outdoor terrace. This complex spatial landscape of rooms, terraces, and courtyards affords the occupants both privacy and companionship in their living quarters.

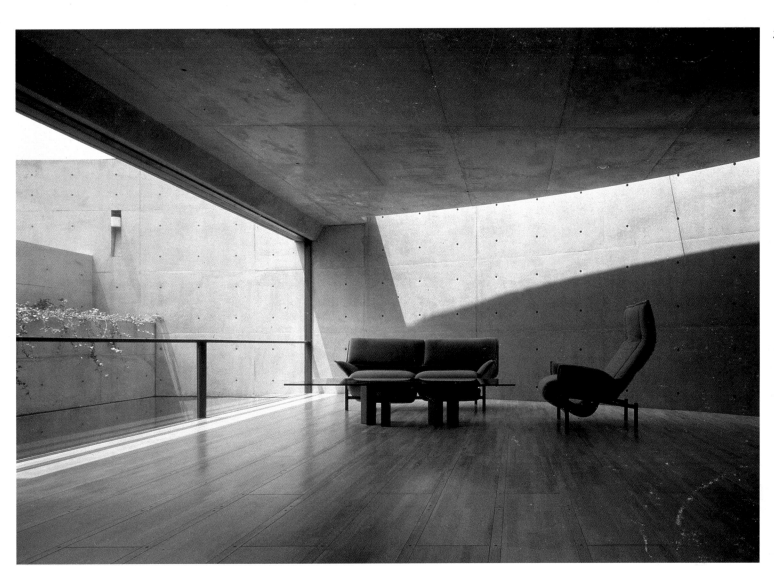

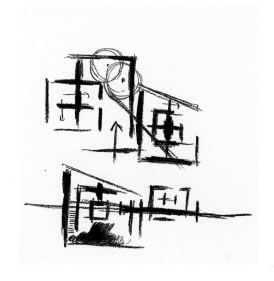

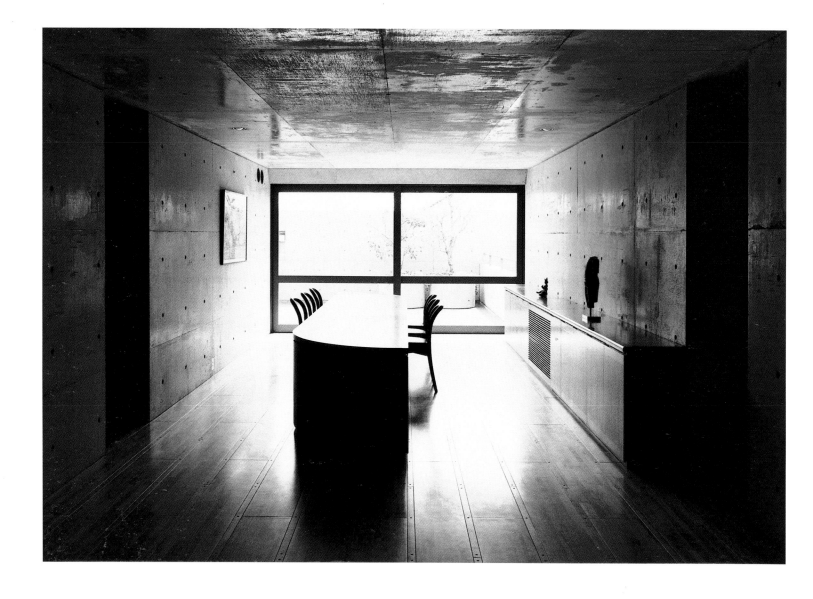

sections

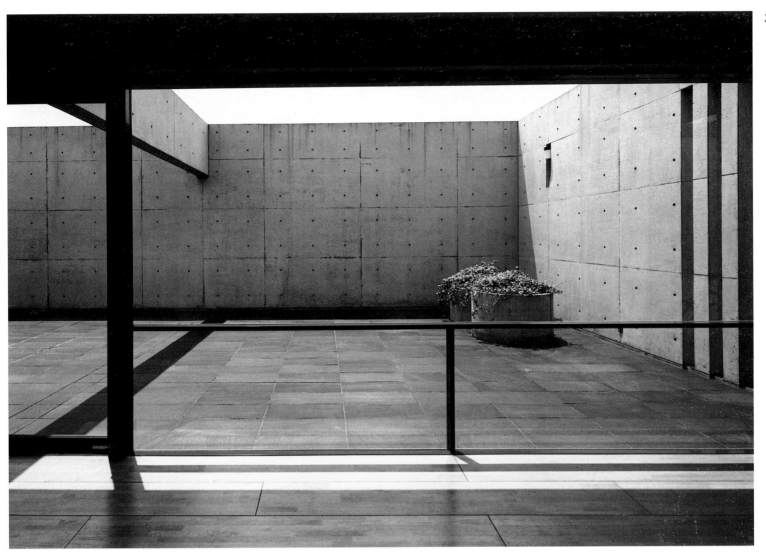

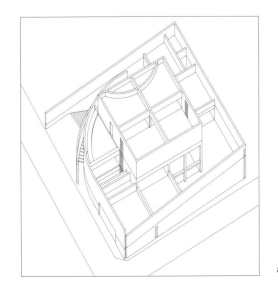

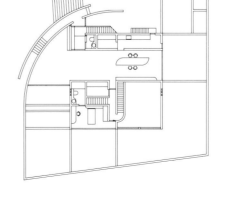

axonometric second-floor plan third-floor plan

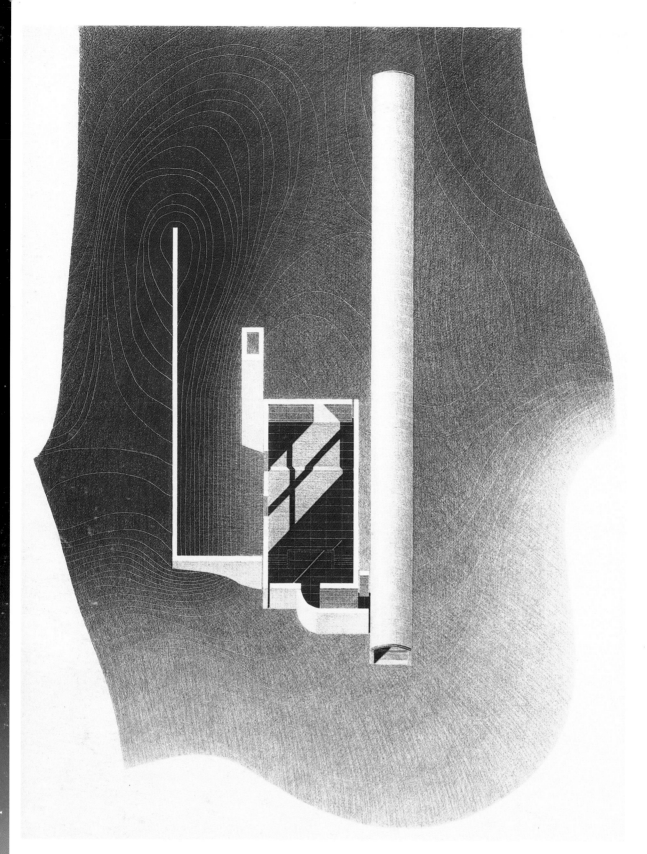

Kōbe, Hyōgo, 1985–86

This small wedding chapel is located near the summit of Mt. Rokko, the highest point in the Kōbe-Ōsaka area. It is part of a resort-hotel complex, and consists of a chapel, bell tower, covered colonnade, and garden wall, all carefully placed on the small level site to harmonize with the surrounding pine trees. The long colonnade, connecting the chapel with the hotel, is composed of frosted-glass walls between concrete frames and a shallow-vaulted frosted-glass roof; it is open at both ends to allow free circulation of the air.

The concrete chapel, a double cube, sits parallel to the evenly lit colonnade. A large window in the center of one side wall bathes the otherwise dark chapel in north light and affords a view of the landscape, partially enclosed by a low freestanding garden wall. Behind the altar, a concrete wall—hung with a thin metal cross— is lit from above by natural light streaming down its textured surface from a narrow glazed opening in the roof.

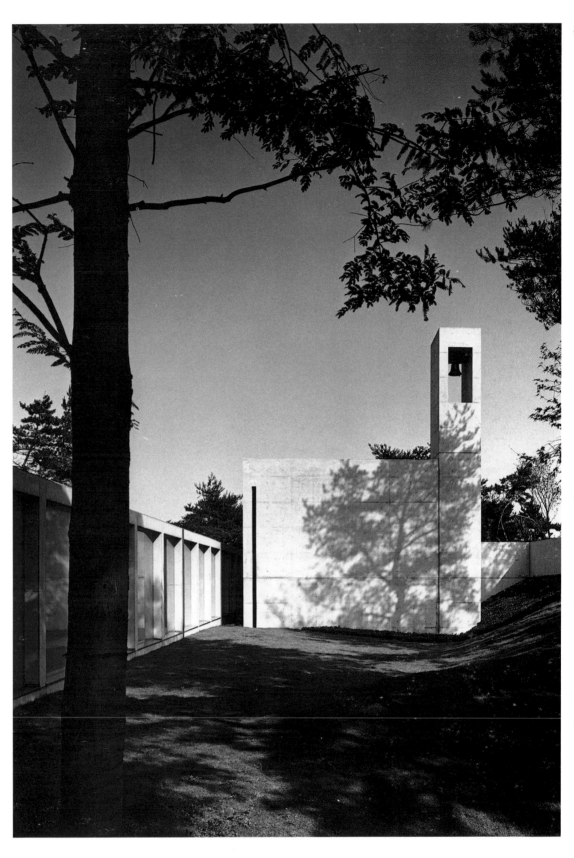

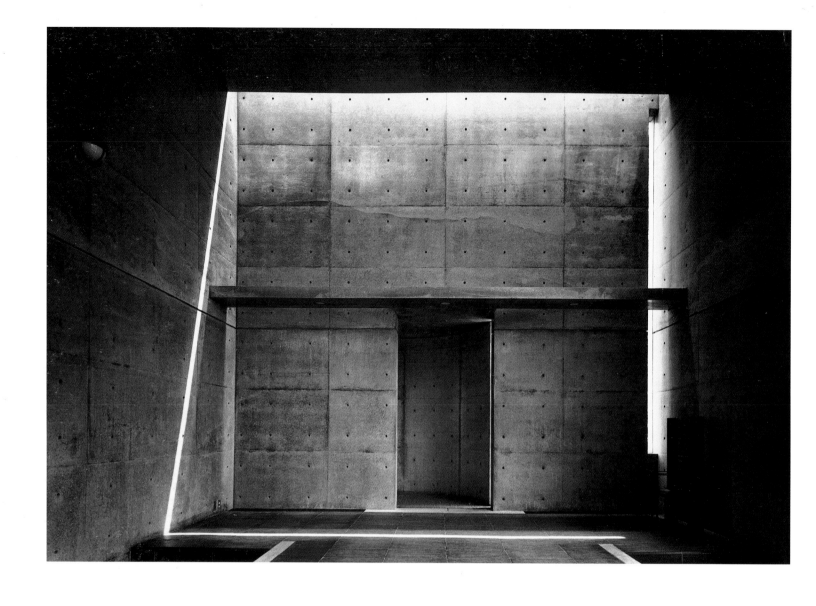

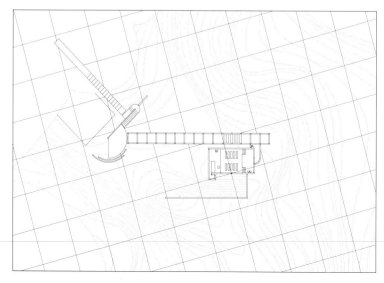

site plan

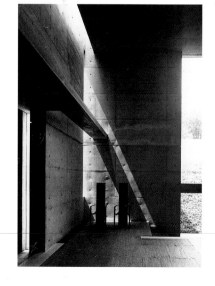

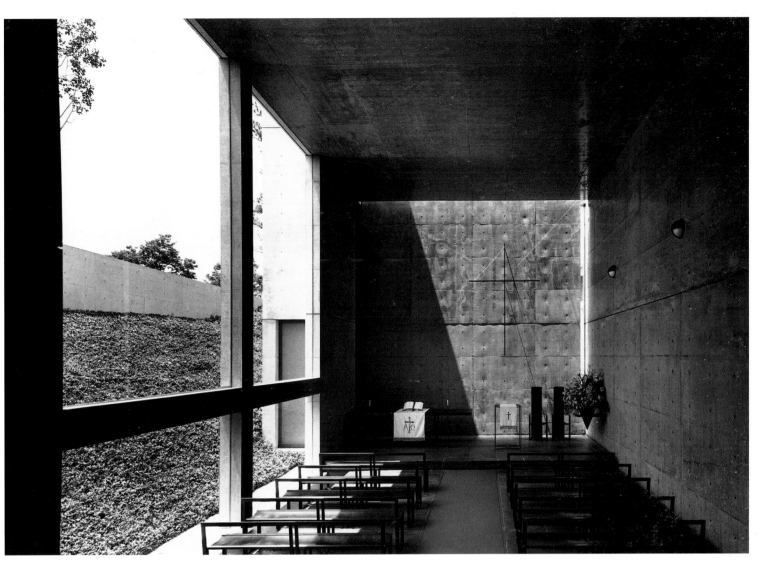

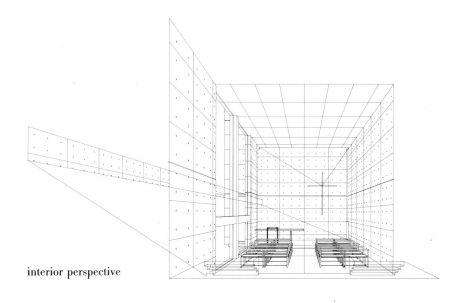

interior perspective

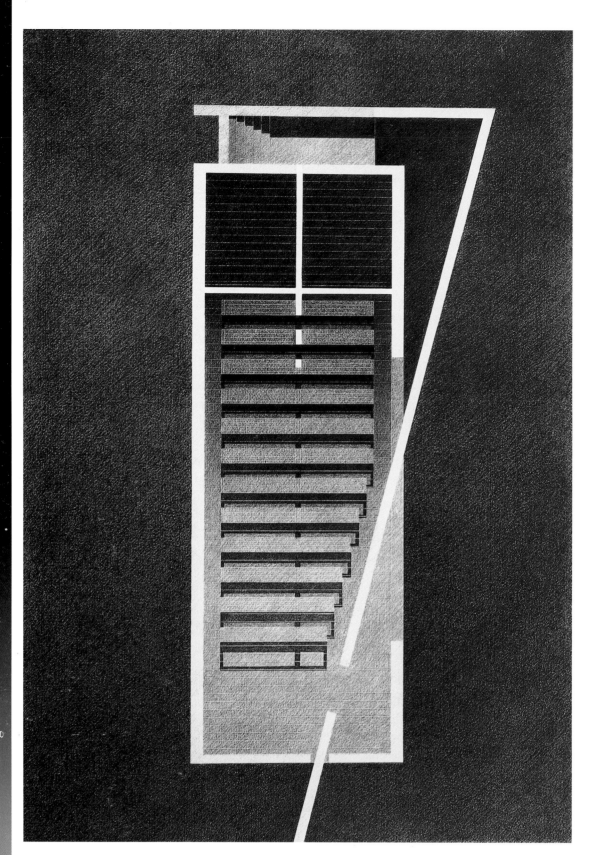

Ibaraki, Ōsaka, 1987–89

This chapel is a freestanding annex to an existing church and vicarage in a quiet residential suburb of Ōsaka. It consists of a rectangular concrete volume (a triple cube), penetrated at two points by an obliquely-angled freestanding wall that divides the space into the chapel and a small triangular entry space. Glazed openings at the points of intersection—approximately the mid-point of the side wall and at the end wall nearest the entry—provide light for the otherwise dark interior. Inside, the tall narrow space slopes downward to the altar at the south end. The entire height and width of the wall behind the altar is penetrated by horizontal and vertical glazed openings that form a cross. The glowing light of the large cross creates a powerful image facing the seated worshippers. The floor and benches, made of the rough wood planks used for the scaffolding, complement and contrast with the cast-concrete walls.

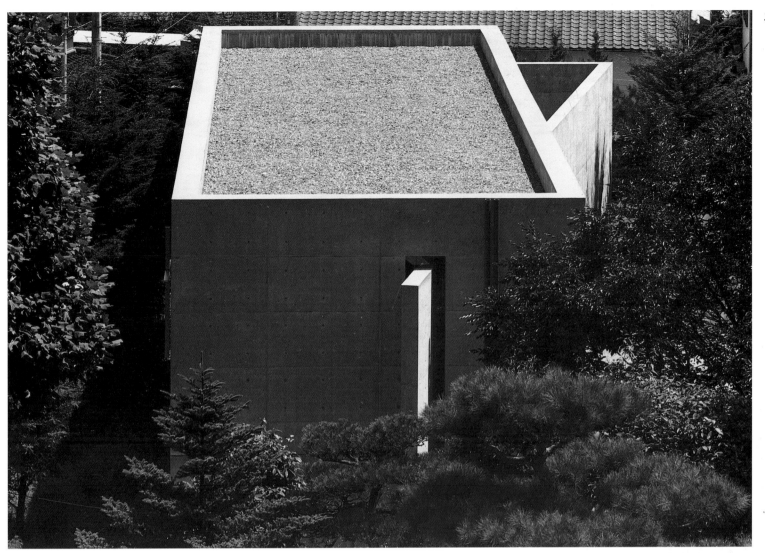

site plan

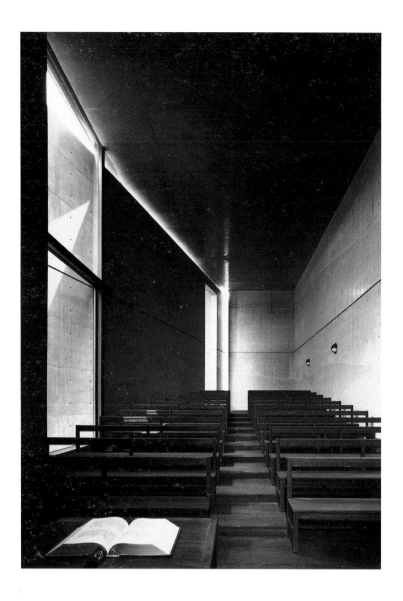

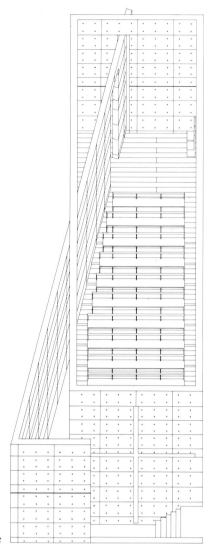

axonometric

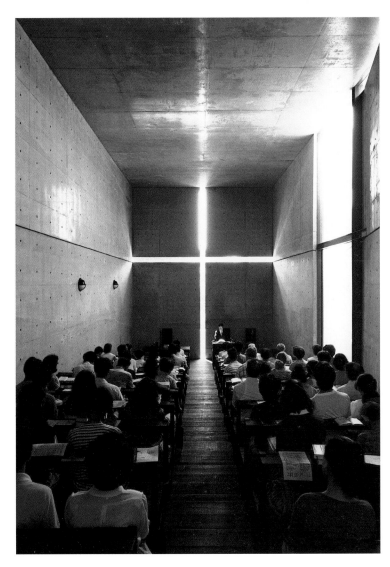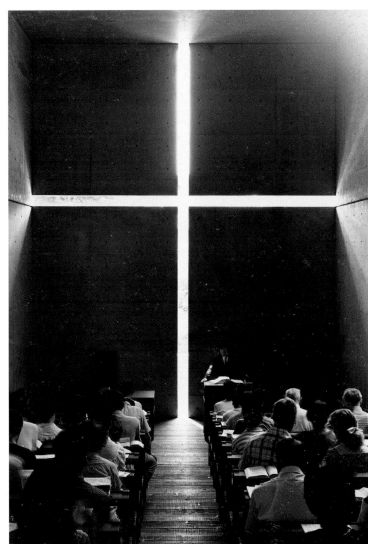

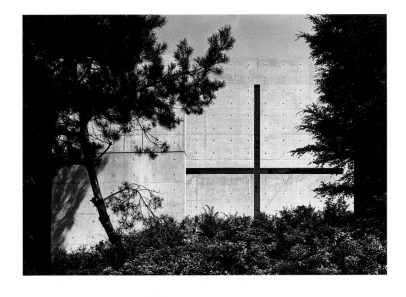

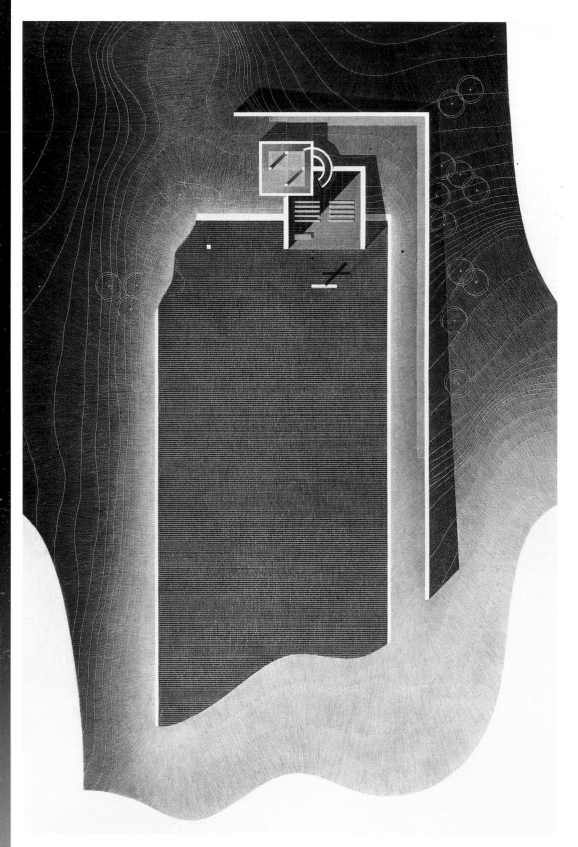

Tomamu, Hokkaidō, 1985–88; Theater, Project 1987

Located on a plain in the Yūbari Mountains in Hokkaidō, this church is part of a year-round resort. The structure consists — in plan — of two overlapping squares: the larger, partly projecting out into an artificial pond, houses the chapel, and the smaller contains the entry and the changing and waiting rooms. A freestanding L-shaped wall wraps around the back of the building and one side of the pond. The church is approached from the back, and entry involves a circuitous route: a counter-clockwise ascent to the top of the smaller volume through a glass-enclosed space open to the sky, with views of the pond and the distant mountains. In this space are four large concrete crosses arranged in a square formation and almost touching. From this point, the visitor descends two levels to emerge at the back of the chapel. The wall behind the altar is constructed entirely of glass, affording a dramatic panorama of the pond with a large cross set into the water. The glass wall itself, spanned by a cruciform mullion, can slide to the side, like a giant *shōji* screen, opening the chapel toward nature.

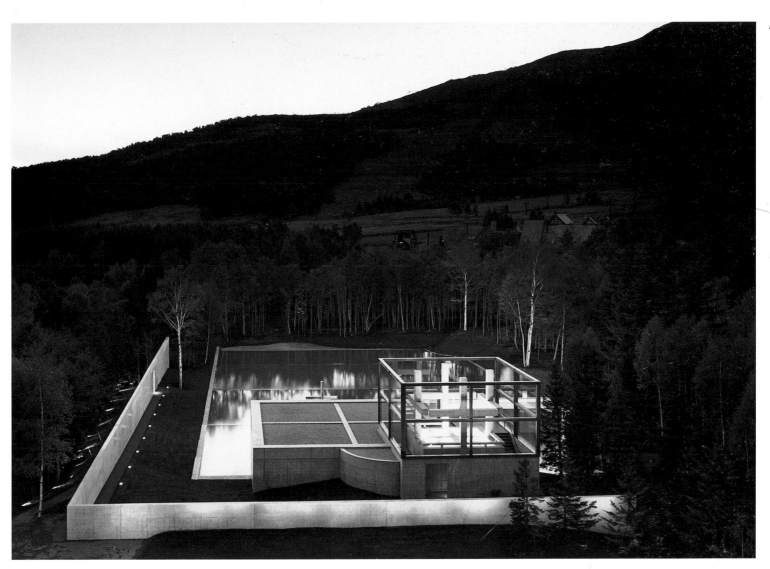

A 6,000-seat semicircular theater, northwest of the church, is
designed to accommodate open-air concerts and fashion shows, and
skating events in winter. Set on a fan-shaped artificial pond, this
amphitheater is intersected by a long bridgelike stage and a
freestanding colonnade. A site wall points toward the church complex
and turns at a sharp angle into the axis of the stage, tying the two
projects together.

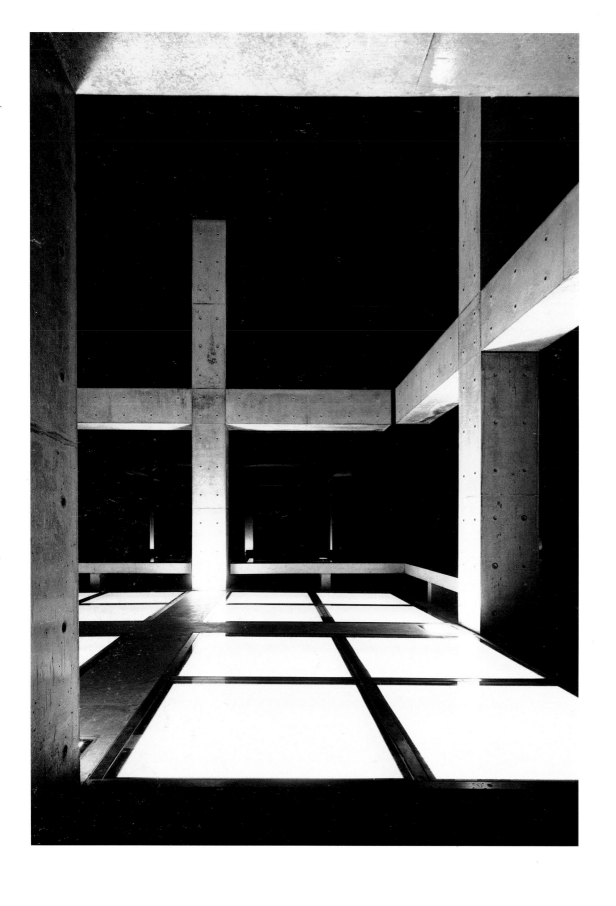

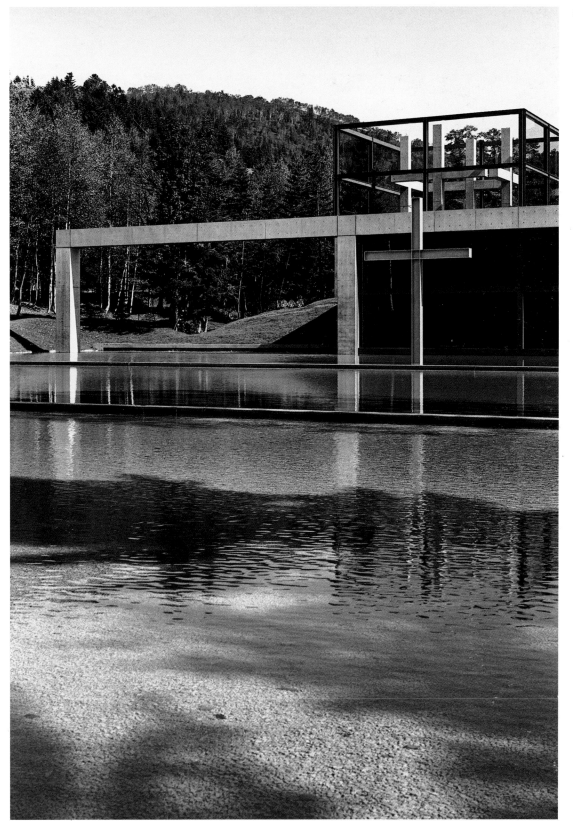

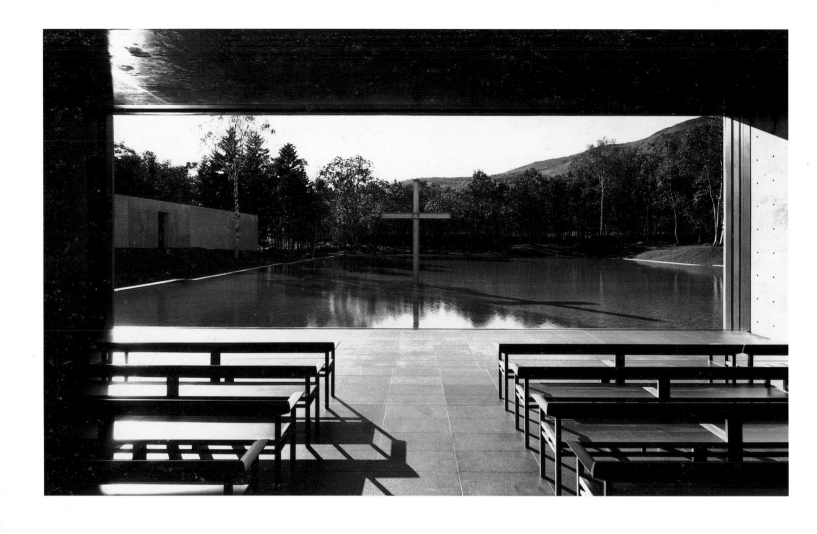

elevation and section

axonometric

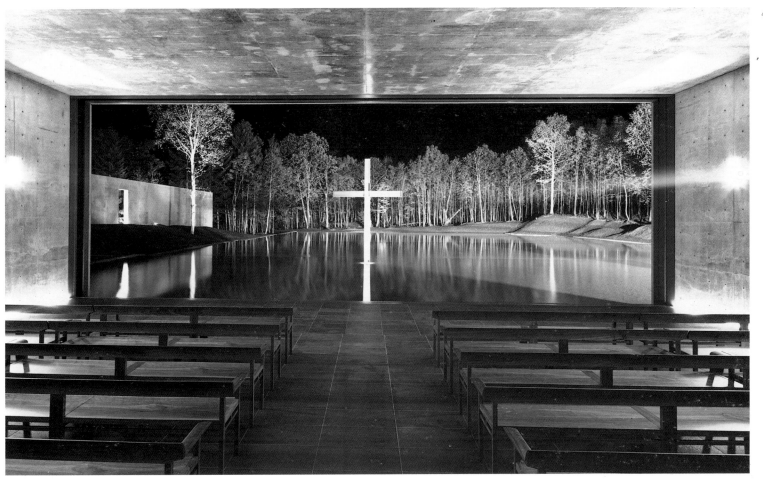

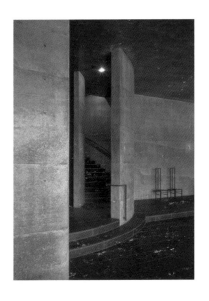

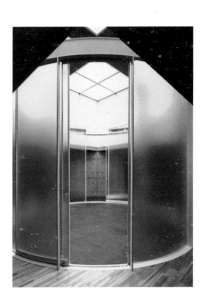

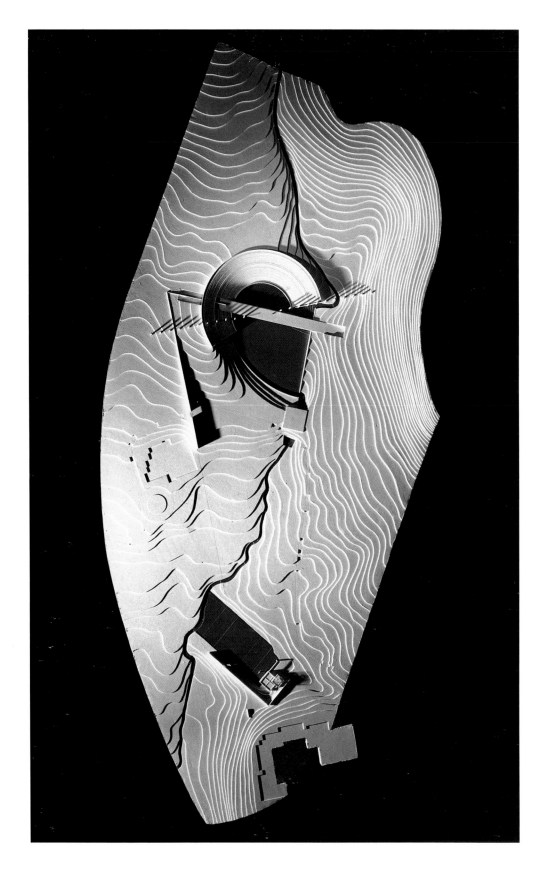

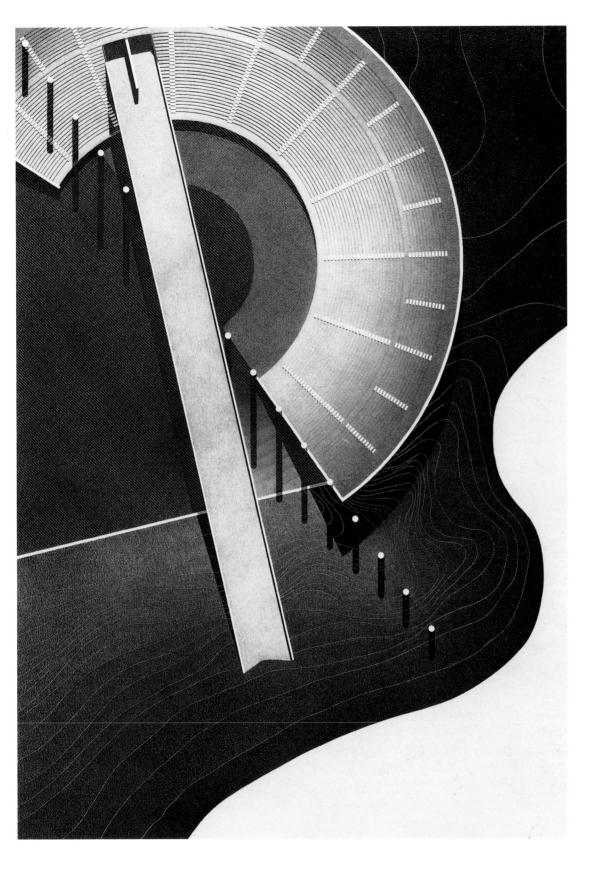

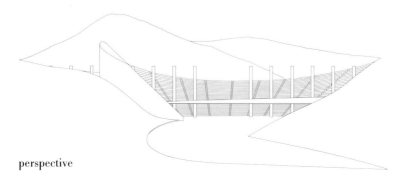

perspective

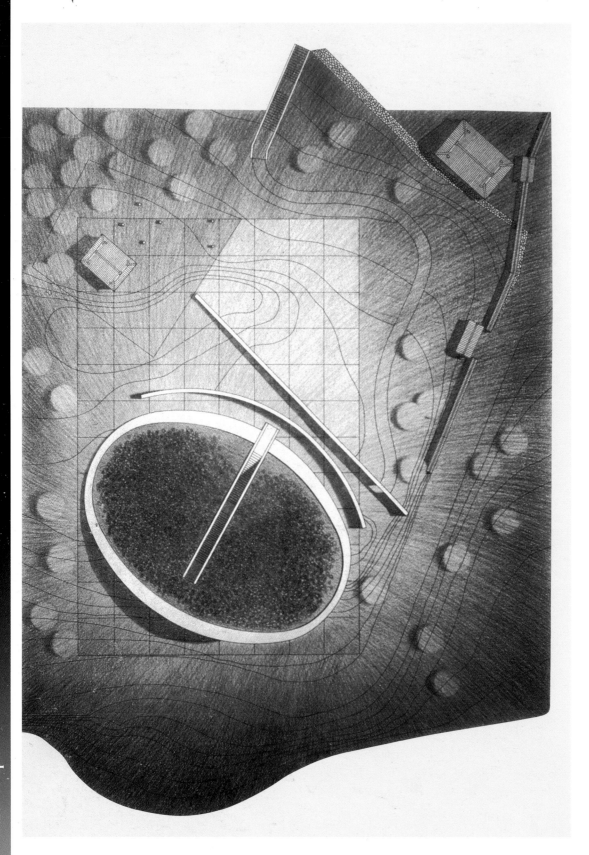

Higashiura-cho, Hyōgo, 1989–91 (under construction)

This project for a new main hall for Hompukuji, an existing Buddhist temple of the Old Shingon sect, is located on the northeastern part of Awaji Island. The site of the new hall is above the existing compound on a hill that affords a sweeping view of Ōsaka Bay. The hall itself, however, is placed underground beneath a large oval lotus pond.

The approach to the hall is elaborate. A path of white sand winds up the hill behind the existing temple and leads to an opening at one end of a long straight freestanding wall. Another wall, behind the first, follows the curve of the pond beyond it. The path continues between the two walls and then doubles back along the edge of the pond to the point from which a stair descends straight down into its center.

This approach to the sanctuary brings the visitor to a red-washed, pillared hall. A Buddha is placed in the center of the hall with its back to the west, where a single corner opening allows the entry of natural light. At the end of the day, light suffuses the hall in a reddish glow, and the pillars cast long shadows in the underground space.

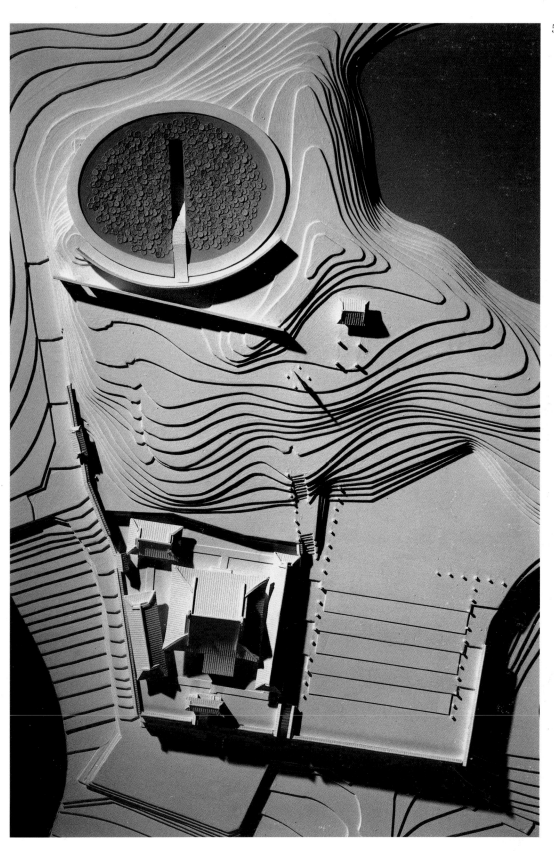

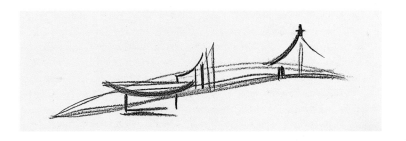

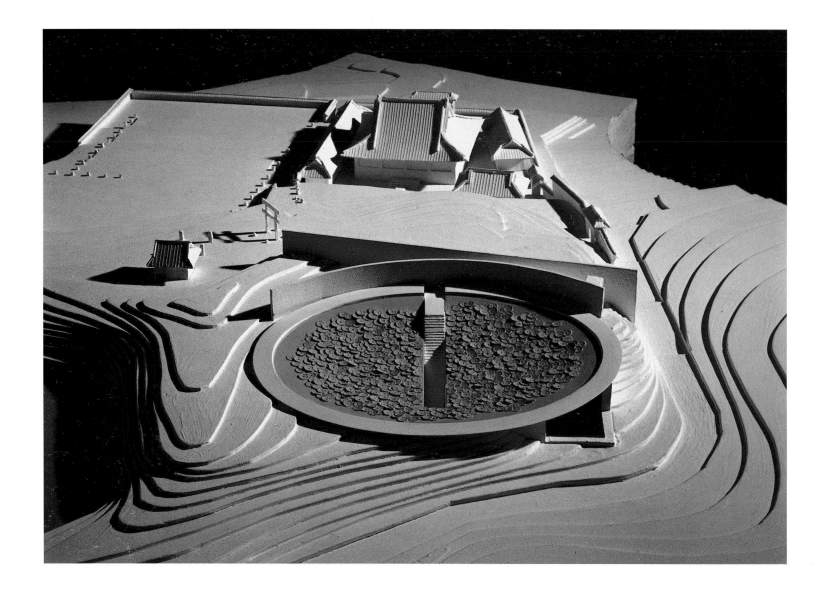

lower-level plan

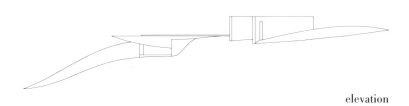

elevation

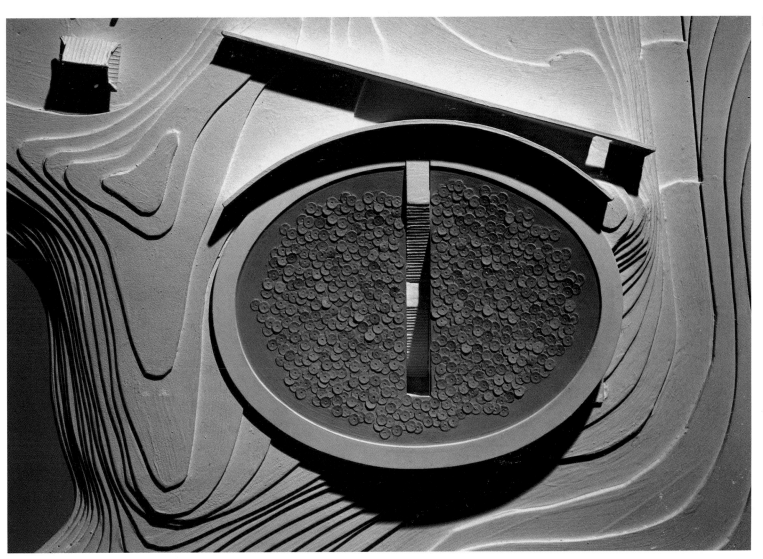

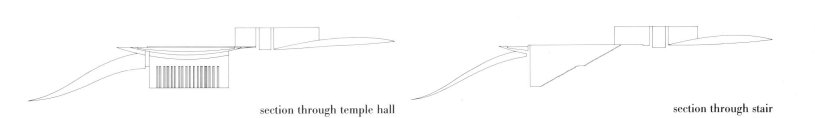

section through temple hall section through stair

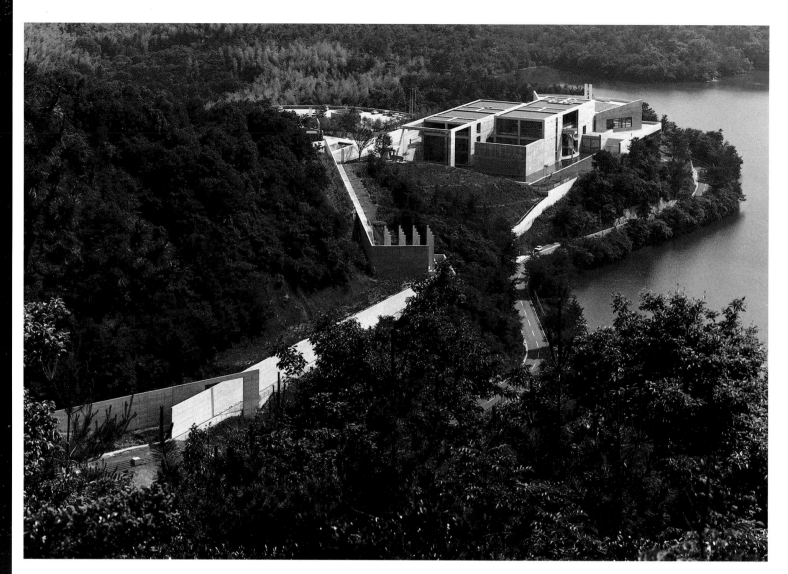

site plan

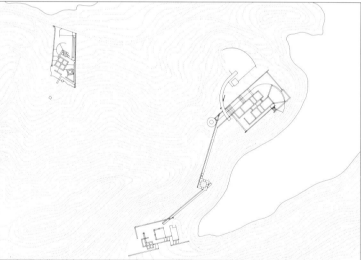

Himeji, Hyōgo, 1987–89

Beautifully sited on a hill overlooking a lake, the Children's Museum is a cultural facility for the artistic education of young people. The facility consists of the main museum buildings, a workshop complex at the back of the site, and extensive walls and paths linking the two.

The museum contains a library, an indoor theater, a multipurpose hall, a restaurant, and numerous education and play spaces. An outdoor theater is placed on the roof. Composed primarily of two parallel rectangular volumes, each of which is divided, the complex actually has four structures joined by a roofed, cruciform entry space and by decks and outside staircases. A broad set of stairs accompanied by cascading pools of water provides entry into the museum's various levels.

A long, walled pathway from the museum is punctuated by a walled plaza containing a grid of pillars, which serves as a connection

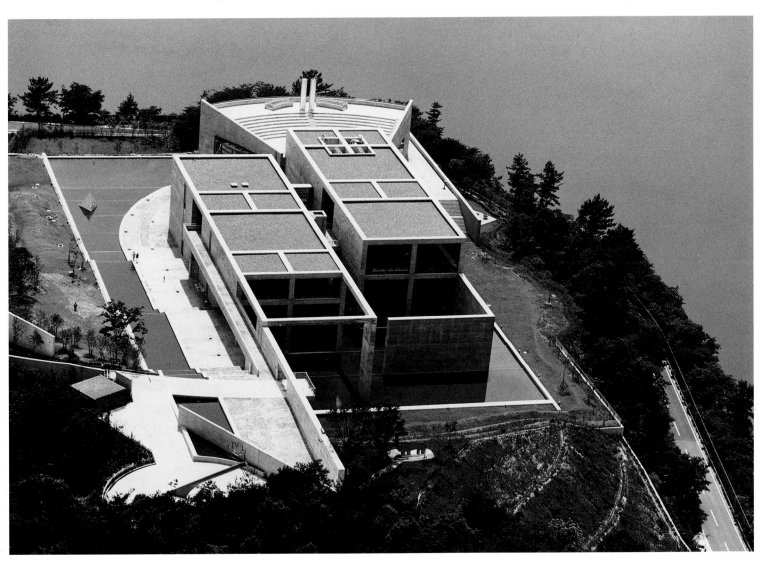

between the two groups of buildings. The two-story workshop is adjacent to a grass-covered area facing the lake and the museum. This building has indoor and outdoor work spaces. An observation deck on the second floor affords a dramatic vista of the lake and the distant mountains. On another part of the site, 1,000 feet southeast of the museum, a Seminar House, or student residence, is under construction.

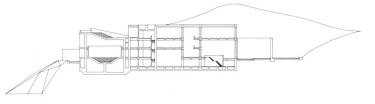

longitudinal section

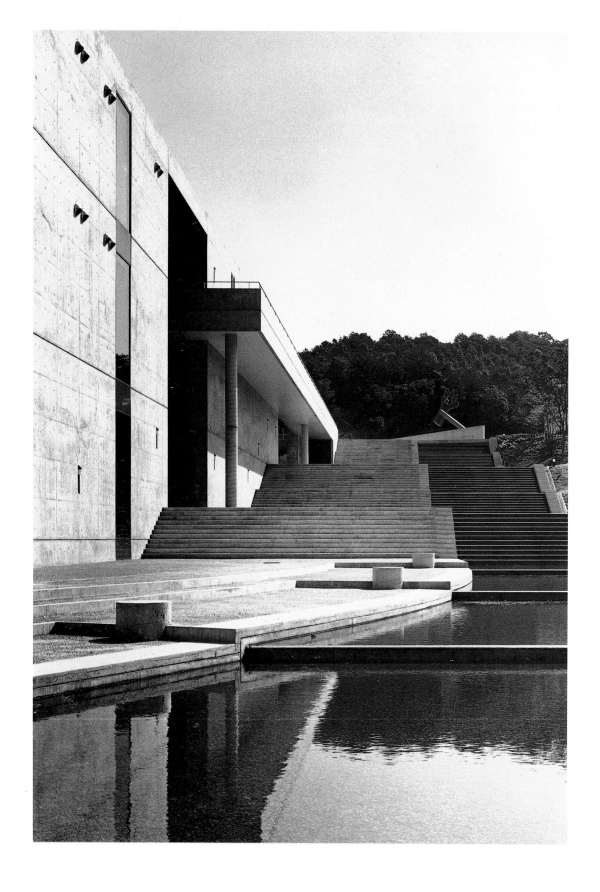

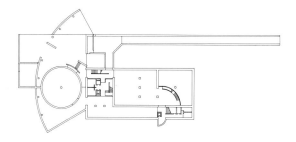

lower-level plan

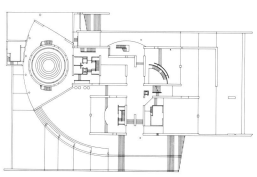

first-floor plan

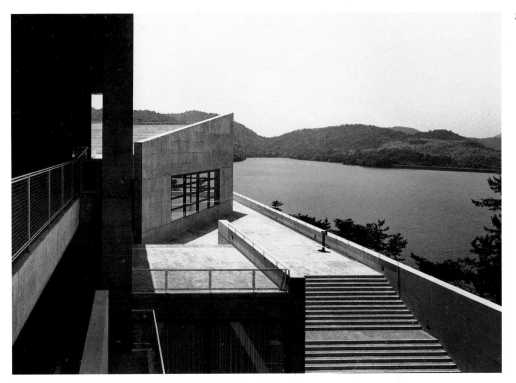

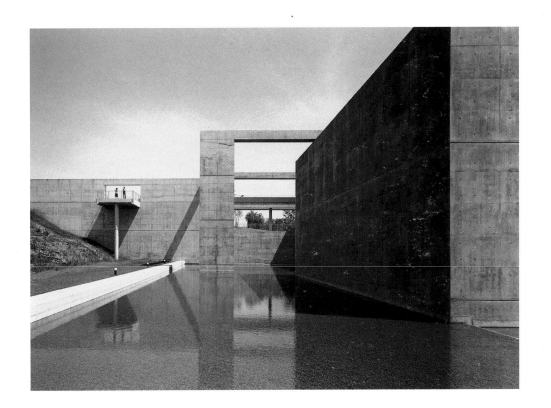

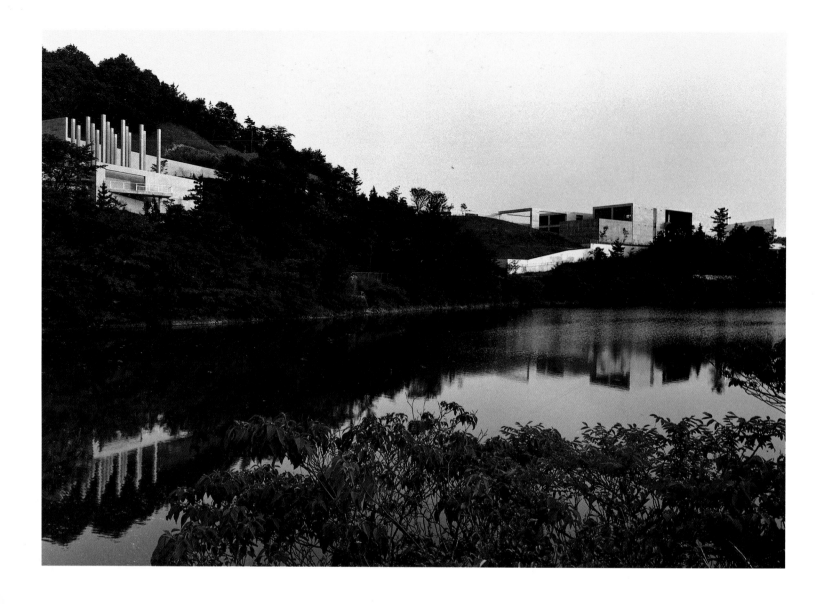

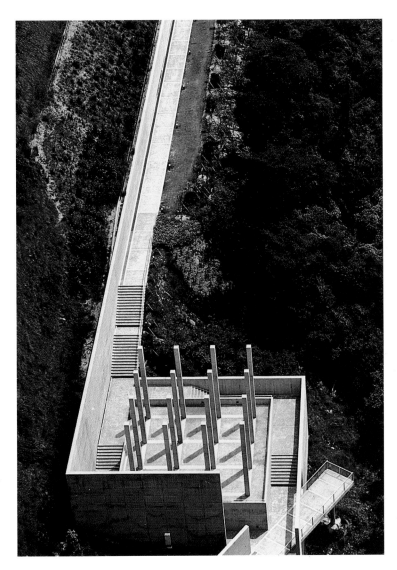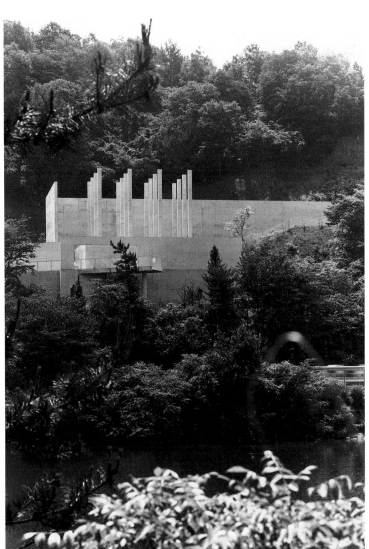

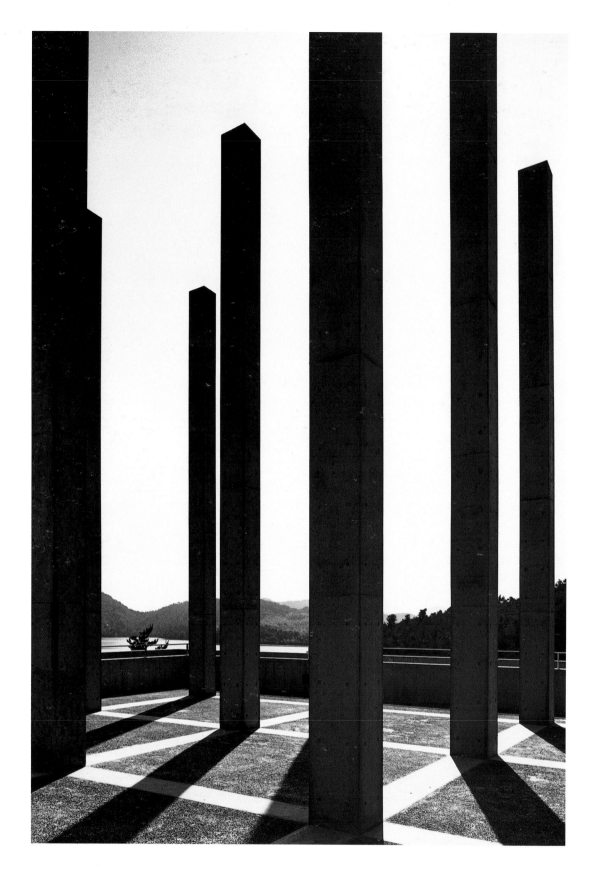

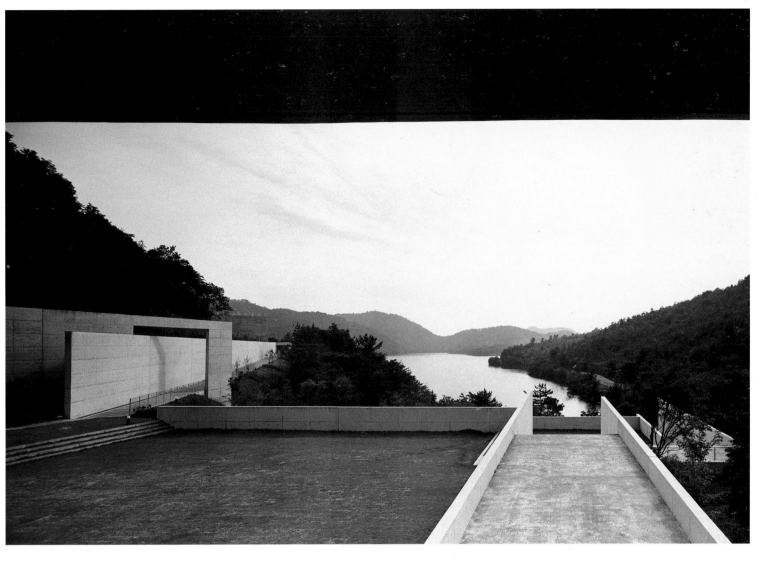

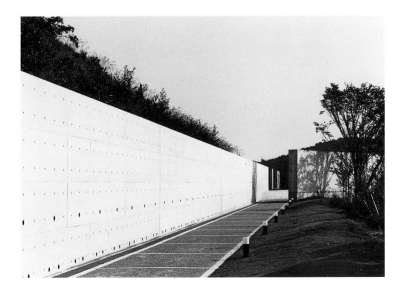

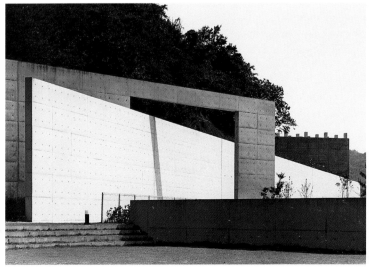

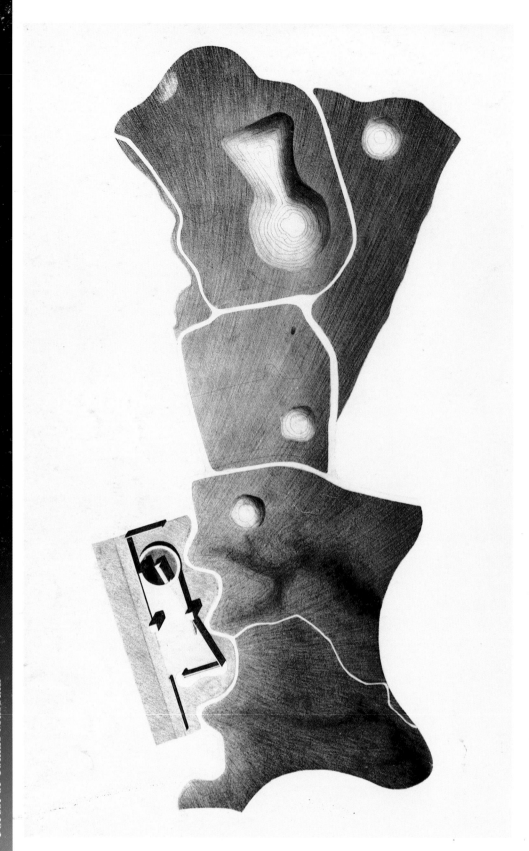

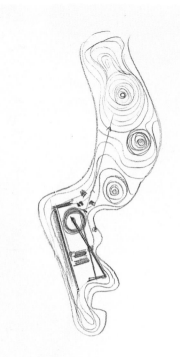

Kumamoto, 1989–91 (under construction)

The purpose of the new Forest of Tombs Museum is to preserve and promote understanding of the historic cultural legacy of the Iwabari burial mounds. It is located near the tomb group— eight round burial mounds surrounding the Futago-zuka, a much larger keyhole-shaped tumulus (*kofun*), which ranks as one of Japan's most famous because of the beauty of its form and setting.

The intent is to display undisturbed the site of the whole tomb group as well as show artifacts and re-creations of the interiors of the tombs themselves. In order not to intrude on the site any more than necessary, the museum was designed as a raised platform from the top of which the tombs and their surroundings can be viewed, and the parking area was placed far from the facility below the natural plateau formed by the site. Approaching the museum on foot,

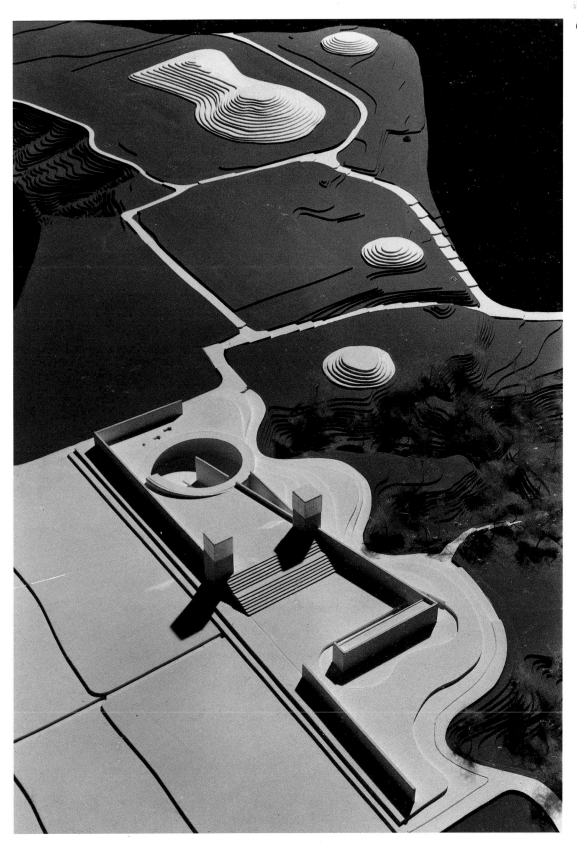

visitors pass through a lush green forest, symbolizing a transition
and boundary between the present and the past.
 At the building itself, a broad set of stairs leads up to the roof
from which a ramp then descends to a circular courtyard that serves
as a display area for artifacts. Inside the museum, the artifacts
are displayed as they were found in the tombs. The configuration of
the structure repeats the keyhole shape of the Futago-zuka.

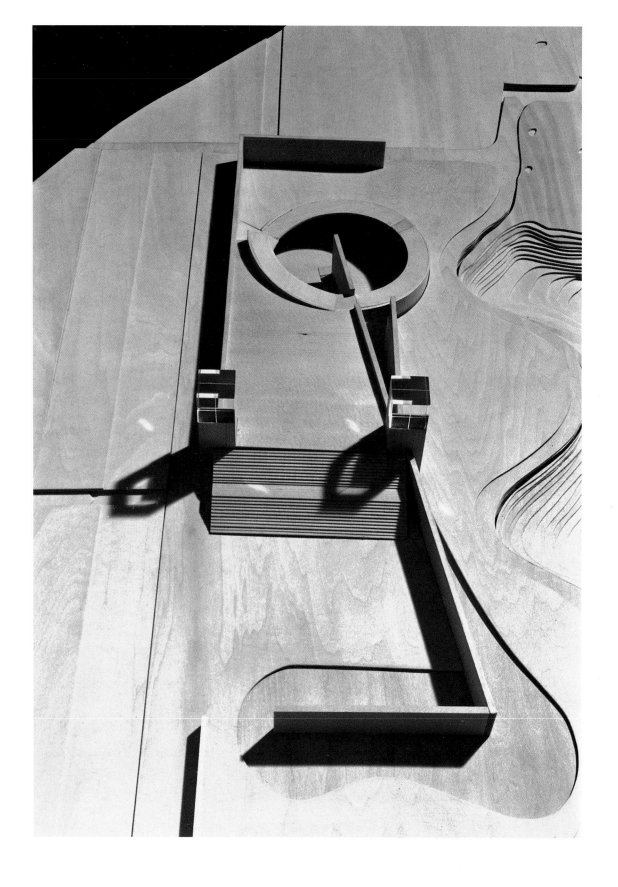

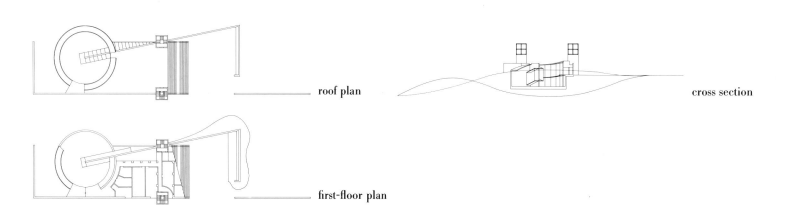

roof plan

cross section

first-floor plan

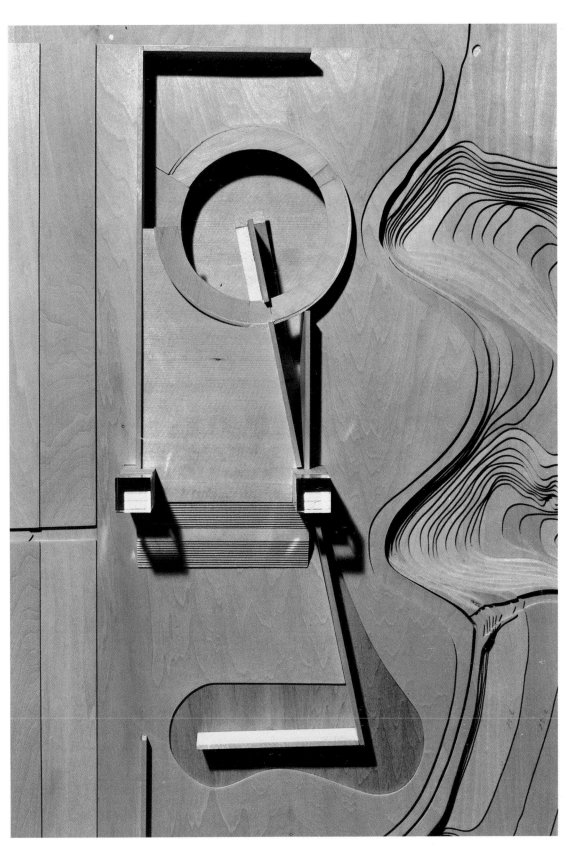

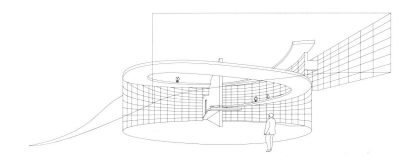

courtyard perspective

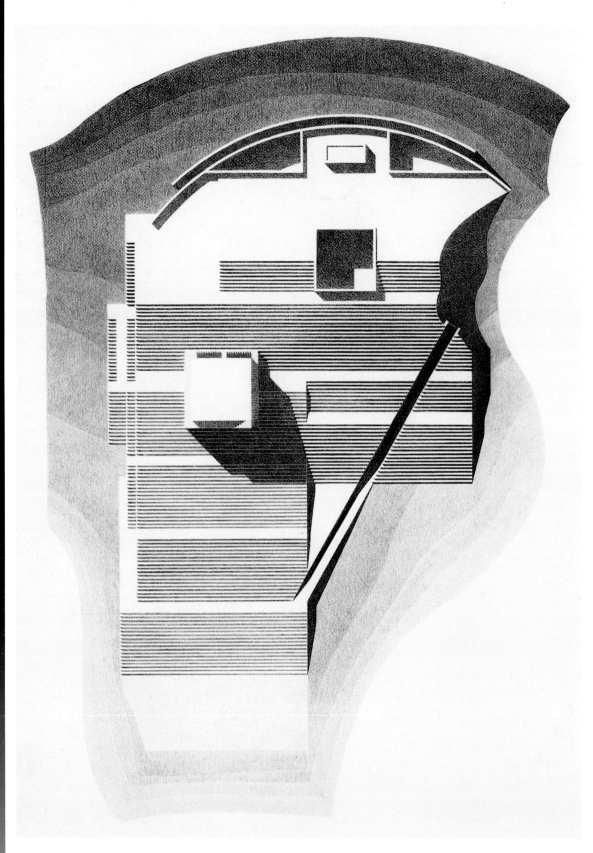

Minami-Kawachi, Ōsaka, 1989–91 (under construction)

Chikatsu-Asuka, in the southern part of Ōsaka prefecture, has one of the best collections of burial mounds (*kofun*) in Japan, with over two hundred examples, including four imperial tombs. The Chikatsu-Asuka Historical Museum is dedicated to exhibiting and researching the Kofun culture of 258–646 A.D., and, like the Forest of Tombs Museum, will not only exhibit the excavated objects, but will act as a place from which the tombs themselves can be viewed in their surroundings. Thus, the building, sited in a basin, was conceived as a hill from which to view the entire excavated area. Its roof, which is really a large stepped plaza, will be used for drama and music festivals as well as lectures and other performances.

Inside the building the display areas are dark and the objects are exhibited as they were found in the tombs. A square light well

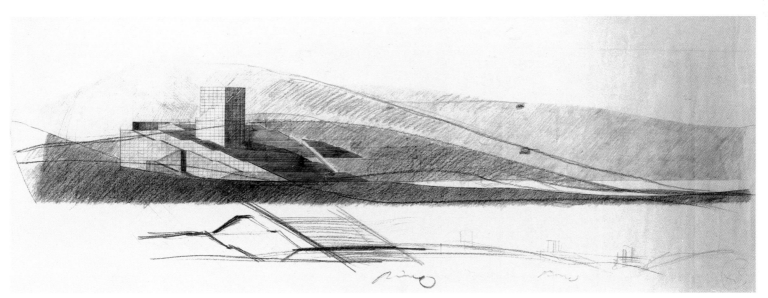

at the top of the plaza penetrates down into the building, providing its only natural light, and echoes the square form of the observation tower, a totally dark, vertical interior space. Nearby, plum trees, a pond, and paths among the surrounding hills envelop this museum in a rich natural and historical environment.

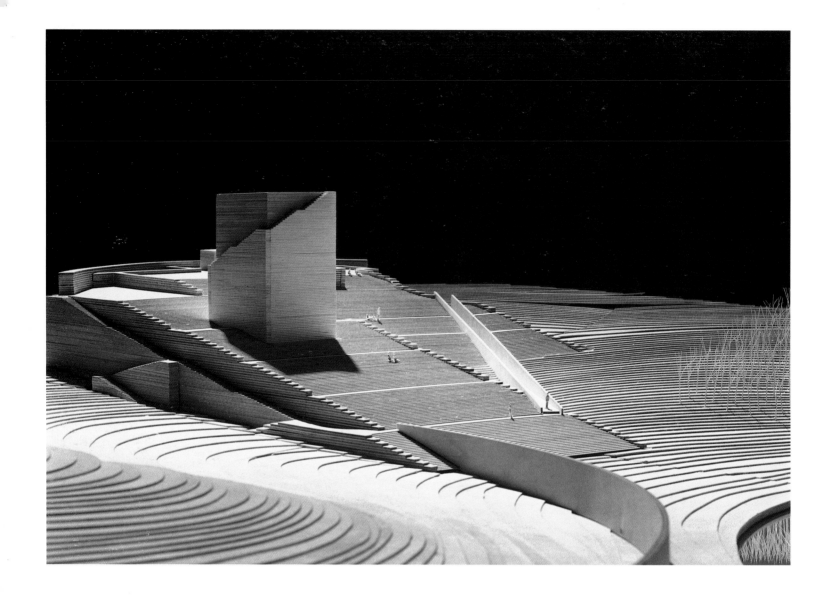

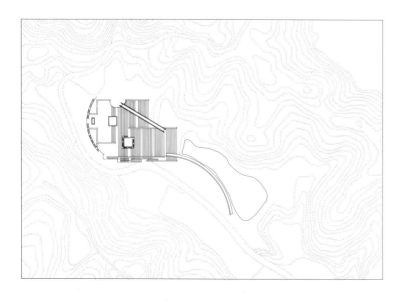

site plan

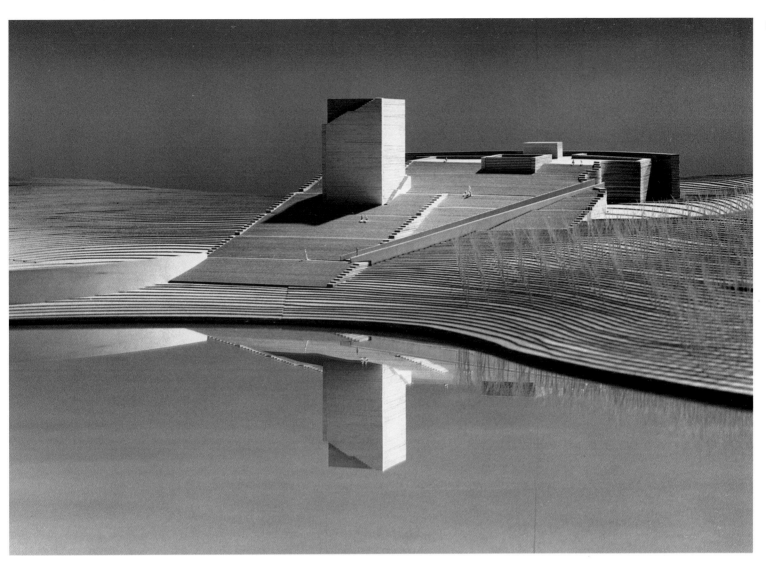

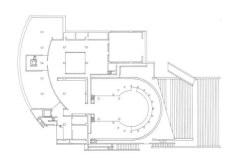

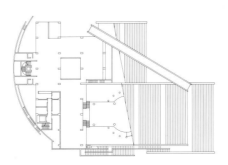

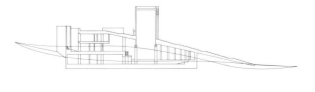

lower-level plan

first-floor plan

longitudinal section

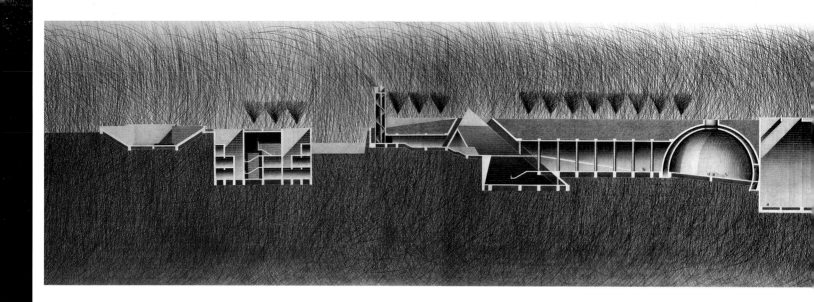

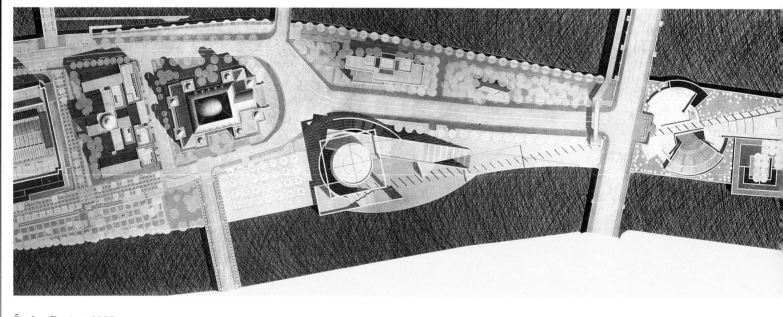

Ōsaka, Project 1988

Nakanoshima is a long island in the middle of the city of Ōsaka, between the Dojima and Tosabori rivers, containing a number of historic buildings. This proposal for an urban park on the island site seeks to retain its historical character and natural beauty while making it into a multi-use facility for the twenty-first century. The site is divided into layers above and below the ground: a water plaza and area for plantings to complement the existing buildings and an underground level to contain an art museum,

conference hall, concert hall, and other facilities. Various openings would introduce natural light to the new cluster below.

The portion of this proposal known as the Urban Egg calls for the installation of an ovoid structure within an existing historic building. The new space would serve as an auditorium hall with a capacity of four hundred. The surrounding spaces would be used as galleries. In this project a dialogue between old and new is created through the introduction of a futuristic form.

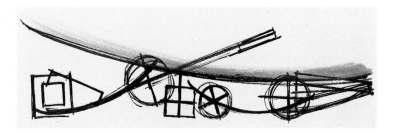

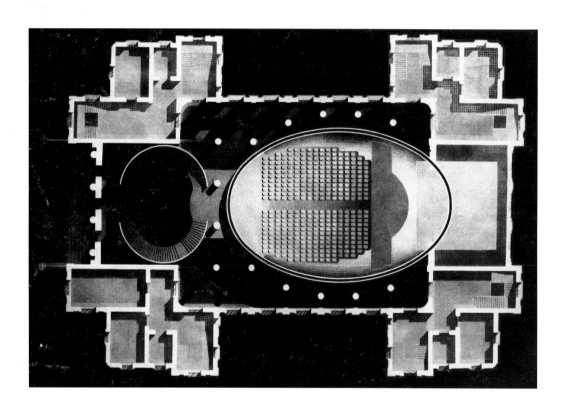

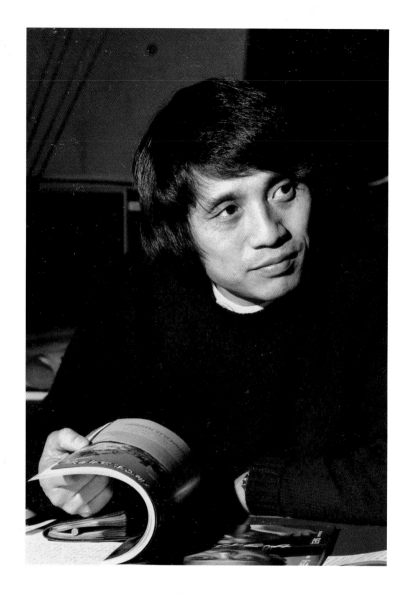

Architectural thought is supported by abstract logic. By abstract I mean to signify a meditative exploration that arrives at a crystallization of the complexity and richness of the world, rather than a reduction of its reality through diminishing its concreteness. Were not the best aspects of modernism produced by such architectural thinking?

Postmodernism emerged in the recent past to denounce the poverty of modernism at a time when that movement was deteriorating, becoming conventionalized, and had abandoned its self-ordained role as a revitalizing cultural force. Modernist architecture had become mechanical, and postmodernist styles endeavored to recover the formal richness that modernism appeared to have discarded. This endeavor undeniably was a step in the right direction — utilizing history, taste, and ornament — and restored to architecture a certain concreteness. Yet this movement, too, has quickly become mired in hackneyed expression, producing a flood of formalistic play that is only confusing rather than inspiring.

The most promising path open to contemporary architecture is that of a development through and beyond modernism. This means replacing the mechanical, lethargic, and mediocre methods to which modernism has succumbed with the kind of abstract, meditative vitality that marked its beginnings, and creating something thought-provoking that will carry our age forward into the twenty-first century. The creation of an architecture able to breathe new vigor into the human spirit should clear a road through the present architectural impasse.

Transparent Logic

Architectural creation is founded in critical action. It is never simply a method of problem-solving whereby given conditions are reduced to technical issues. Architectural creation involves contemplating the origins and essence of a project's functional requirements and the subsequent deter-mination of its essential issues. Only in this way can the architect manifest in the architecture the character of its origins.

In envisioning the Chikatsu-Asuka Historical Museum, Ōsaka, on a site central to early Japanese history, I came to realize the vital importance of establishing an architecture that didn't mar the grandeur of the existing landscape. Therefore, I focused on architecture's power to produce a new landscape, and sought to create a museum that would embrace the entire landscape within the scope of its exhibitions.

In contemporary society, architecture is determined by economic factors and for the most part ruled by standardization and mediocrity. The serious designer must question even the given requirements, and devote deep thought to what is truly being sought. This kind of inquiry will reveal the special character latent in a commission and cast sharp light on the vital role of an intrinsic logic, which can bring the architecture to realization. When logic pervades the design process the result is clarity of structure, or spatial order — apparent not only to perception, but also to reason. A transparent logic that permeates the whole transcends surface beauty, or mere geometry, with its intrinsic importance.

Abstraction

The real world is complex and contradictory. At the core of architectural creation is the transformation of the concreteness of the real through transparent logic into spatial order. This is not an eliminative abstraction but, rather, an attempt at the organization of the real around an intrinsic viewpoint to give it order through abstract power. The starting point of an architectural problem — whether place, nature, lifestyle, or history — is expressed within this development into the abstract. Only an effort of this nature will produce a rich and variable architecture.

In designing a residence — a vessel for human dwelling — I pursue precisely that vital union of abstract geometrical form and daily human activity.

In the Row House (Azuma Residence), Sumiyoshi, I took one of three wood row houses and reconstructed it as a concrete enclosure, attempting to generate a microcosm within it. The house is divided into three sections, the middle section being a courtyard open to the sky. This courtyard is an exterior that fills the interior, and its spatial movement is reversed and discontinuous. A simple geometric form, the concrete box is static; yet as nature participates within it, and as it is activated by human life, its

abstract existence achieves vibrancy in its meeting with concreteness. In this house my chief concern was the degree of austerity of geometric form that could be fused with human life. This concern predominates in my Koshino House, Kidosaki House, in other residential works, and in other types of buildings as well. Geometric abstraction collides with human concreteness, and then the apparent contradiction dissolves around their incongruity. The architecture created at that moment is filled with a space that provokes and inspires.

Nature

I seek to instill the presence of nature within an architecture austerely constructed by means of transparent logic. The elements of nature — water, wind, light, and sky — bring architecture derived from ideological thought down to the ground level of reality and awaken manmade life within it.

The Japanese tradition embraces a different sensibility about nature than that found in the West. Human life is not intended to oppose nature and endeavor to control it, but rather to draw nature into an intimate association in order to find union with it. One can go so far as to say that, in Japan, all forms of spiritual exercise are traditionally carried out within the context of the human interrelationship with nature.

This kind of sensibility has formed a culture that deemphasizes the physical boundary between residence and surrounding nature and establishes instead a spiritual threshold. While screening man's dwelling from nature, it attempts to draw nature inside. There is no clear demarcation between outside and inside, but rather their mutual permeation. Today, unfortunately, nature has lost much of its former abundance, just as we have enfeebled our ability to perceive nature. Contemporary architecture, thus, has a role to play in providing people with architectural places that make them feel the presence of nature. When it does this, architecture transforms nature through abstraction, changing its meaning. When water, wind, light, rain, and other elements of nature are abstracted within architecture, the architecture becomes a place where people and nature confront each other under a sustained sense of tension. I believe it is this feeling of tension that will awaken the spiritual sensibilities latent in contemporary humanity.

At the Children's Museum, Hyōgo, I have arranged each of the architectural elements to allow congenial meetings with water, forest, and sky under ideal conditions. When the presence of architecture transforms a place with a new intensity, the discovery of a new relationship with nature is possible.

Place

The presence of architecture — regardless of its self-contained character — inevitably creates a new landscape. This implies the necessity of discovering the architecture which the site itself is seeking.

The Time's Building, situated on the Takase River in Kyōto, originated out of the involvement its place offered with the delicate current of the nearby river. The building's plaza, where one can dip a hand in the water, the bridgelike attitude of its deck above the current, the horizontal plan of approach from along the river rather than from a road — these elements serve to derive the utmost life from the character of the building's unique setting. The Rokko Housing project was born from attention to an equally singular site, in this case one pitched on a maximum sixty-degree slope. Underlying its design was the idea of sinking the building in along the slope, governing its projection above the ground in order to merge it into the surrounding cover of dense forest. This affords each dwelling unit an optimal view of the ocean from a terrace provided by its neighbor's roof. Each of my projects, whether the Children's Museum, Hyōgo, the Forest of Tombs Museum, Kumamoto, the Raika Headquarters Building, or Festival, Okinawa, results from an endeavor to create a new landscape by bringing the character of place fully into play.

I compose the architecture by seeking an essential logic inherent in the place. The architectural pursuit implies a responsibility to find and draw out a site's formal characteristics, along with its cultural traditions, climate, and natural environmental features, the city structure that forms its backdrop, and the living patterns and age-old customs that people will carry into the future. Without sentimentality, I aspire to transform place through architecture to the level of the abstract and universal. Only in this way can architecture repudiate the realm of industrial technology to become "grand art" in its truest sense.

Photograph Credits

The photographers and sources for the works reproduced in this volume are listed alphabetically below, followed by the page on which the image appears. The Museum wishes to thank Tadao Ando Architect & Associates for supplying the photographs credited to Mitsuo Matsuoka and Tomio Ohashi or copyright *The Japan Architect*.

Courtesy Tadao Ando Architect & Associates, Ōsaka:
10, 12, 13, 14, 15 top, 16 top, 17 top and center, 10, 27 top and bottom left, 28 bottom left and right, 32 bottom left and right, 33 bottom left, center, and right, 34, 36 bottom left, 37 bottom, 39 bottom left, 40 right, 42, 44 bottom, 46 bottom left and right, 47 bottom left, 49, 50, 52 bottom left and right, 53 bottom left and right, 54 bottom, 55 bottom, 56 bottom left and right, 62 left, 64 center and bottom left and right, 65 bottom, 66, 67 top, 68 bottom left and right, 69 bottom left and right, 70–71 top and center, 72, 74.

© *The Japan Architect*, Shinkenchiku-sha Co., Ltd., Tokyo: 27 top right.

K & L Photo, New York: From Arthur Drexler, *The Architecture of Japan* (New York, The Museum of Modern Art, 1955, p. 38, courtesy Ise Shrine), 18 top; from J. Hillier, *Hokusai: Paintings, Drawings and Woodcuts*, 3rd ed. (Oxford, Phaidon Press, 1985, p. 43, Art Institute of Chicago), 18 bottom; from Mitsuo Inoue, *Space in Japanese Architecture*, trans. Hiroshi Watanabe (New York and Tokyo, Weatherhill, 1985, p. 10), 11; from Teiji Itoh, *Traditional Japanese Houses*, ed. and phot. Yukio Futagawa (New York, Rizzoli, 1980, p. 248), 15 bottom.

Kate Keller, The Museum of Modern Art, New York:
frontispiece, 27 bottom right, 31 bottom, 35 bottom, 39 bottom right, 43 bottom, 45 bottom, 51 bottom, 55 center, 62 right, 67 bottom, 71 bottom.

Hiroshi Kobayashi, © *The Japan Architect*: 26.

Mitsuo Matsuoka: 29 top and bottom right, 31 top, 68 top, 69 top.
Mitsuo Matsuoka, © *The Japan Architect*: 27 center, 29 bottom left.
© Mitsuo Matsuoka: 30, 32 top, 33 top, 35 top, 36 top and bottom right, 37 top, 38 and cover, 39 top, 40 left, 41, 43 top, 44 top, 45 top, 46 top, 47 top and bottom right, 54 top, 55 top, 56 top, 57, 58, 59, 61, 63, 64 top, 65 top.

The Museum of Modern Art, New York: From Bernard Rudofsky, *Architecture Without Architects* (New York, The Museum of Modern Art, 1965, p. 129), 16 bottom.

Tomio Ohashi: 51 top, 52 top, 53 top, 73.
© Tomio Ohashi: (1981) 28 top, (1988) 48, (1990) 60.

Pietinen, courtesy Museum of Finnish Architecture, Helsinki: 17 bottom.